ILLUSTRATED TALES OF
CHESHIRE

DAVID PAUL

AMBERLEY

First published 2019

Amberley Publishing
The Hill, Stroud
Gloucestershire, GL5 4EP

www.amberley-books.com

British Library Cataloguing in Publication Data.
A catalogue record for this book is available from the British Library.

ISBN 978 1 4456 7855 9 (paperback)
ISBN 978 1 4456 7856 6 (ebook)

Typesetting by Aura Technology and Software Services, India.
Printed in Great Britain.

Contents

Introduction 5

The Great Fire of Nantwich 6

The Lady's Shelf 10

The Sandbach Crosses 13

Cheshire Wakes 16

The Plague in Cheshire 19

The Boggart in Gower Hey Wood 21

The Stalybridge Bread Riots 23

The Haunted Farm at Godley 25

The Wizard of the Edge 27

'Souling' in Cheshire 29

Chester's Eastgate Clock 31

Murder at Knutsford 33

The Pepper Gate Elopement 35

The Muzzled Bear of Brereton 37

Simnel Sunday 40

Northwich Salt Mines 41

The Postal Houses of Stockport 43

The Legend of Beeston Castle 45

The Murder of Mary Malpas 49

The Superstitious Farmers of Cheshire 53

Gentleman Edward Higgins 55

The Cheshire Doctoress 58

Easter Customs of Cheshire 60

The Tragedy at Over Cotton Mill 62

The Hoylake Lifeboat Disaster of 1906 64

Whippings in Altrincham Market Place 66

Luddites at Stalybridge 69

The Old Woman of Delamere Forest 71

The Winsford Waterman's Strike 74

The Headless Woman of Tarvin 77

The Witches Trial of 1656 80

Tales of Marbury 83

Christmas Customs of Cheshire 87

Vale Royal Abbey 89

Select Bibliography 94

Acknowledgements 95

About the Author 96

Introduction

The flourishing county of Cheshire, with its rolling countryside, lush pastures, picturesque villages and scattered market towns, has a rural economy that is famous for the production of Cheshire cheese, milk and ice cream, all of which are enjoyed and savoured throughout the country. The county also has a diverse industrial base, which ranges from mining much of the county's salt in and around the area of Northwich, to the production of one of the world's most famous car marques – Bentley. More recently, Chester itself has become one of the country's top visitor destinations.

The county also boasts a particularly rich cultural heritage, which is as varied and complex as the county itself, and shaped over the years by many factors such as the Roman occupation, the geography and geology of the county and the role played by the established Church and other faith groups. It is because of these and other contributory factors that the customs, legends and traditions of the county have grown and developed. Sadly, many are now either forgotten or have become moribund, but it is hoped that the mélange of stories that follow may preserve, in some small way, a few of the more important legends, customs, mysteries and traditions peculiar to this enchanting county.

This book does not purport, in any way, to be an academic text, but is aimed at the general reader.

David Paul

The Great Fire of Nantwich

One of the most cataclysmic events to befall the town of Nantwich started at six o'clock on the evening of Tuesday 10 December 1583, when Mr Nycolas Browne, who lived in the Waterlode area of the town, accidentally set fire to his home. Accounts vary as to the cause of the fire, but most agree that the accident occurred when he was brewing beer in his kitchen, whereas another report suggests that he was in the process of cooking his evening meal.

There was a particularly strong westerly wind that night, and most of the wattle and daub properties in the town were built closely together, which had the effect of fanning the flames and carrying them along the thatched roofs with great rapidity. It first spread up High Street, then through the markets and on to Beam Street and Pepper Street. It then travelled along Pillory Street and Hospital Street until finally reaching Briar Hall.

While the fire raged for the next fifteen hours, somewhere in the region of 600 buildings were destroyed or severely damaged. The fire was set to smoulder on for at least another twenty days. The following morning, the only buildings that remained on the east side of the river were the church, the corn mill, the grammar school and a few domestic residences at the far end of Beam Street,

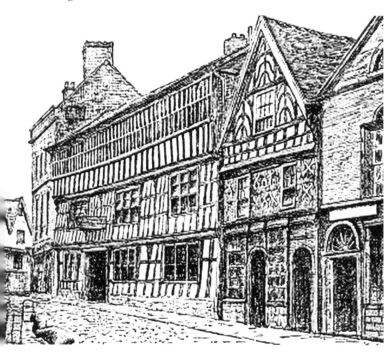

Crown Hotel, *c.* 1583.

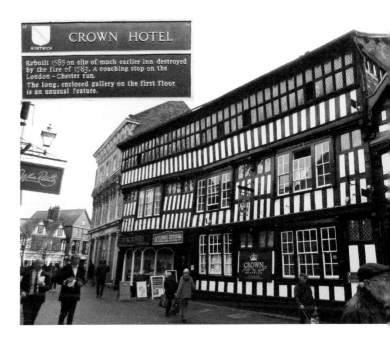

Restored Crown Hotel, Nantwich.

Hospital Street and Pillory Street. Half of the town's population, almost 900 people, were rendered homeless as a direct result of the fire.

As soon as the alarm was raised people came rushing out of their homes in order to escape from the rapidly approaching inferno. Very soon a human chain was formed to carry water from the nearby River Weaver to the centre of the town.

In addition to the vast number of private houses and places of business that were consumed by the fire, seven of the town's public houses were also razed to the ground including The Beyr (Bear), where Jon Seckerston was the owner. He kept four great bears in his stable for the barbaric 'sport' of bear-baiting. However, as the fire approached, he, or one of his customers, released them from their holding chains, causing untold terror, as the bears rampaged wildly, totally bewildered by the scenes confronting them. When local women, who had joined the chain, heard of this, they downed their leather water buckets and fled to safety, only venturing out to help when protected by men carrying weapons. In the confusion and mayhem that ensued, Maggie Duckworth ran directly into the bears' path. Her charred and mauled body was found a few days later. Mrs Anne Lovatt was recorded as being the first person to die in the fire. She was in the line of people fetching water when the wall from a partially burnt building collapsed on her. It was also reported that an elderly widow, Alice Blagge, died from injuries sustained during the fire, although official records assert that only two people died during the fire.

When news of the fire came to the notice of Elizabeth I, she immediately ordered that a nationwide fund be launched in order to help with the rebuilding of the town, making a personal donation of £1,000. The queen also granted

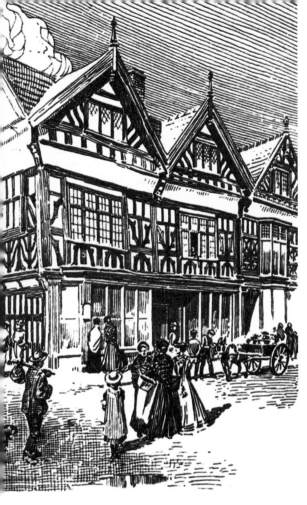

Left: High Street, Nantwich, *c.* 1583.

Below: High Street, Nantwich.

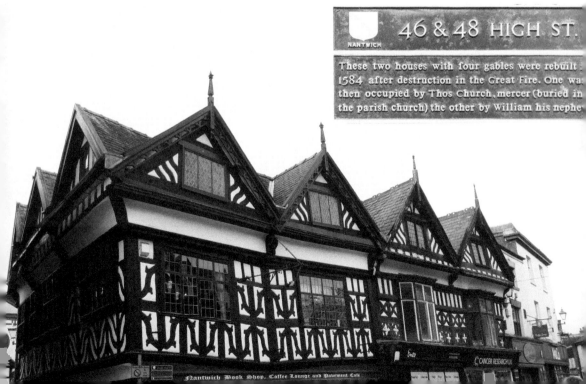

46 & 48 HIGH ST.

NANTWICH

These two houses with four gables were rebuilt
1584 after destruction in the Great Fire. One wa
then occupied by Thos Church, mercer (buried in
the parish church) the other by William his nephe

licenses to six local people, giving them the right to export grain, free of duty, for a period of ten years. The profits were then added to the appeal fund. As a final act of benevolence, the queen granted permission for trees from the nearby royal forest in Delamere to be felled and used in the rebuilding programme. One of the main streets of the town, Beam Street, had been renamed to reflect the fact that timber taken from the forest had been transported along that route.

The Bishop of Chester appointed four collectors, two of whom are recorded as being Sir Hugh Cholmondeley Kt. and Mr John Maisterson. Their principal tasks were to oversee the buying of trees for the rebuilding of the town, and to distribute poor relief where and when necessary. Once rebuilding had started, it took a further three years to complete the programme. The medieval street pattern was closely followed in the rebuilding of the town. Unfortunately, on the third anniversary of the outbreak of the fire, John Maisterson died, never having seen the completed rebuilding. The most costly building to be rebuilt was The Crowne, which cost £314 3s 4d (£314.17).

Townsman Thomas Cleese recorded his gratitude to the queen in an inscription on the front of his new house, which can still be seen opposite the entrance to Castle Street.

It is a matter of record that on the day before the fire, Monday 9 December 1583, every cat in and around the vicinity of Nantwich departed the town, not returning until months later – strange!

Location: CW5 5AS

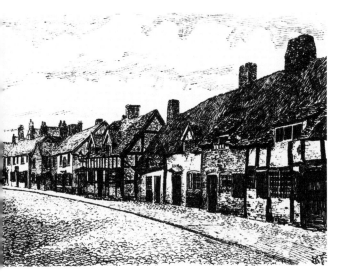

Above: Hospital Street, Nantwich, *c.* 1583.

Right: Loyal declaration by Thomas Cleese.

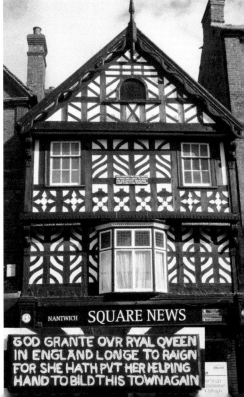

The Lady's Shelf

The archipelago known as the Hilbre Islands lies off the mainland of the Wirral Peninsula. The three islands are Hilbre Island itself, the largest and westernmost; then comes Little Hilbre; and south of both is Little Eye. Hilbre Island is around 1 mile from Red Rocks.

It is believed that the name, Hilbre, derives from the medieval chapel that was built on the island and dedicated to St Hildeburgh, who was an Anglo-Saxon holy woman. Hildeburgh lived on the island in the seventh century as an anchorite. Following her death, the island became known as Hildeburgheye or Hildeburgh's Island.

Early in the eleventh century a cell for Benedictine monks was established on Hilbre Island. Their church was, in all probability, a dependency of Chester Cathedral, acting as a chapel of ease to Chircheb (West Kirby). The Domesday Book refers to Chircheb as having two churches, noting that one was in the town and the other, probably Hilbre, was on an island in the sea.

It was on this island that, after prayers, one of the monks found a dying maiden on a ledge of rock, obviously having been washed up by the high tide the previous evening. The monk ministered to her as best as he could and listened to her tale before she died from her injuries.

The lady, her father's only daughter, had fallen in love with her father's squire. The squire, Edgar, was an orphan, but nonetheless, he had been brought up by the knight as if he were his own child. Throughout their childhood, the two had

Looking from Little Hilbre towards Hilbre Island.

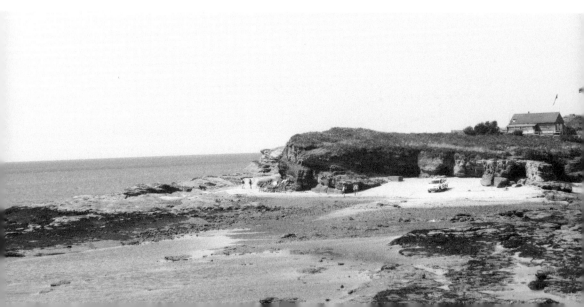

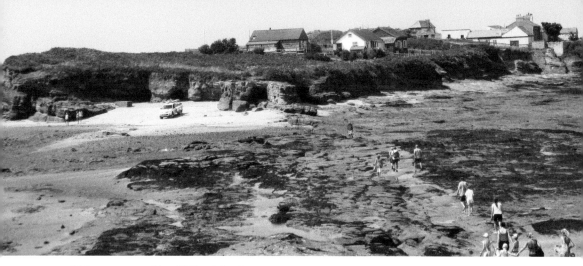

Visitors approaching Hilbre Island.

grown up together and, ultimately, had fallen in love. When the knight was told of this romance he was outraged, as he wanted his daughter to marry Llewellyn, who was a rich Welsh knight.

One day, off the Point of Aire, when the knight and his daughter were sailing on their way to Llewellyn's home, her father lied to her, and told her that Edgar, the squire, was dead. On hearing the news, the daughter was distraught and, not able to contain her anguish and inner turmoil, she fainted and in doing so rocked the boat such that, in the high winds, she was carried overboard. Her father cried after her that Edgar was not dead, but he could neither rescue nor alert his daughter to his treacherous lies.

The Lady's Shelf.

Sandstone ledges near to the Lady's Shelf.

That same evening, she was washed up onto a ledge on Hilbre Island, and it was on the following morning that the monk found her. Being much weakened by her news and subsequent ordeal, she told her story, but then died in the arms of the Benedictine.

When Henry VIII embarked upon the Dissolution of the Monasteries, two monks were given leave to remain on the island on the understanding that they kept a beacon lit during the hours of darkness to prevent shipping in the Dee estuary from foundering on the dangerous rocks in that area. The last monks finally vacated the island in the mid-sixteenth century. During the thirteenth and fourteenth centuries the island was a place of pilgrimage.

St Hildeburgh's is still the parish church of Hoylake.

Location: CH48 8BW

The Sandbach Crosses

The two crosses that are located in Sandbach marketplace, situated to the west of the church, are some of the most interesting monuments of their kind to be found in the whole of the country. They were first mentioned by Smith in 1585, but later in the seventeenth century they were violently pulled down, probably by Puritans. Many of the fragments were used for building purposes within the town itself, but the greater part of the larger cross and some sections of the smaller one were removed by Sir John Crewe to Ukington, near to Tarporley, where they were used to adorn the grounds. After Sir John's death in 1711, the remaining pieces were taken by Revd John Allen, rector of Tarporley, where they resided for some time before being taken to Oulton. Following discussion with the then owner, Sir John Grey Egerton, Bart., they were restored to their proper place. Sir John allowed townsfolk from Sandbach to collect all of the fragments, which were then re-erected. The restoration work was carried out under the direction of Mr John Palmer, the Manchester architect, with Mr Ormerod superintending the work. A meeting was held in the market hall on Monday 9 September 1816

Below left: The Sandbach Crosses.

Below right: The Sandbach Crosses, 2018.

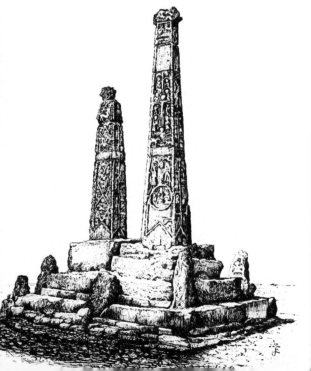

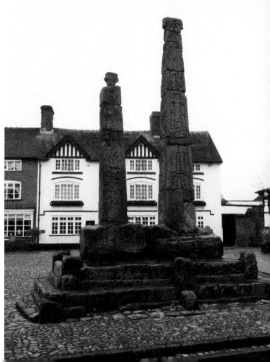

when a vote of thanks was extended to Sir John Grey Egerton, Bart., 'for the handsome manner in which he had restored those parts of their cross'. It was also resolved 'that George Ormerod, Esq., be desired to accept the thanks of the meeting for the kindness with which he has offered to superintend the re-erection of the mutilated crosses, and that a brass plate with a suitable inscription should be affixed to the larger pillar.'

The crosses consist of two upright pillars, each of which is fixed in a thick heavy stone socket. The sockets themselves have then been placed on a wide platform. The height of the taller cross is 16 feet 8 inches, and that of the smaller cross is 11 feet 11 inches.

The Great Cross, as it is sometimes known, depicts the chief truths of Christianity on three sides: the story of John the Baptist in the wilderness; the Annunciation; the Birth of Christ; and, in all probability, a number of scenes illustrating Betrayal, Trial and Crucifixion. It is possible that some of the, now destroyed, sections also depicted the Resurrection. The final side shows the descent of the Holy Ghost to the Apostles. The smaller cross, in addition to showing a number of scriptural subjects, would appear to illustrate some local historical

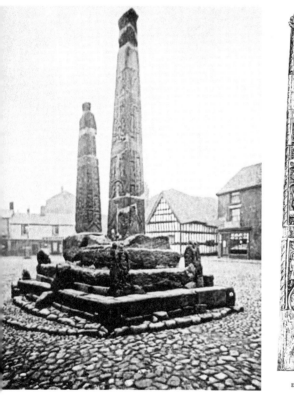
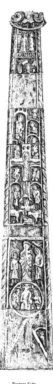
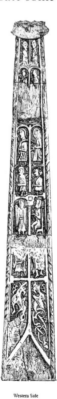
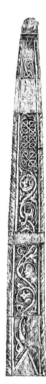

Eastern Side Western Side Southern Side Northern Side

Above left: General view of the Sandbach Crosses, *c.* 1904.

Above right: Detail on the Great Cross, Sandbach.

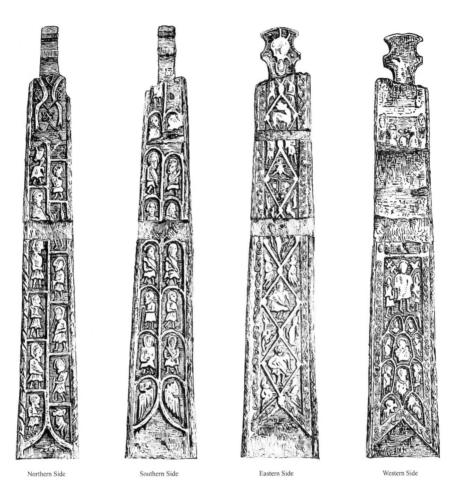

| Northern Side | Southern Side | Eastern Side | Western Side |

Detail on the Small Cross, Sandbach.

facts that, in all probability, commemorate the return of Peada, who was the son of Penda, King of Mercia. Peada had visited Oswy, King of Northumbria, where he fell in love with Alchfleda, who was the king's daughter. The main condition for the sanctioning of their marriage was that he espoused the Christian religion, which he readily agreed to. On his return to his own land, he was accompanied by four priests, to whom he had given permission to preach the gospel of Christ throughout his dominion. It would appear, therefore, that the erection of the crosses commemorate, in some way, the introduction of Christianity into Mercia by Peada in the year 653, although it is not thought that the crosses themselves were erected until later in the century.

Location: CW11 1JP

Cheshire Wakes

Many of the old customs observed in Cheshire have now ceased or fallen into disrepute. In fact, during the sixteenth century monastic documents held at St Albans stated: 'because of their fickleness, the people of those parts (Cheshire) are more ready and accustomed to doing such things because of local disputes and former wars. They more readily resort to arms and are more difficult to control than other people'.

The 'wakes' was a holiday, usually lasting for a couple of days, and held on or near to the local parish church's patronal dedication festival. Wakes were held throughout the year, however, the church authorities had difficulty in accommodating so many different dates and, in 1536, had the Act of Convocation

Bunbury Church from the west.

passed, which ordered parishes to hold its wake on the first Sunday in October, without reference to its patronal link. As the wakes were the one time in the year when country folk could rub shoulders with the wider community, the act didn't go down too well. Although the wakes presented an opportunity for countrywomen to enjoy buying goods that were normally not available to them, it also had the effect of acting like a magnet for less desirable elements in town to start drink-related brawls and fights. The problems associated with the wakes became so widespread that a sanctimonious person from Great Budworth issued a list of seven reasons as to why village people shouldn't attend them:

1. Drawing together multitudes of persons for no good reason.
2. Excessive drinking.
3. Encouraging all the works of the flesh.
4. Losing much precious time.
5. Cursing, swearing and blasphemy.
6. Doing the works of the Devil.
7. Wasting a great deal of money.

Wakes week was an important event in the life of villages and towns. In Bunbury for example, a handbill featured the following advertisement:

> Wanted a person to conduct the performances at Bunbury Wake, which will be celebrated on Monday, Tuesday, and Wednesday, the 20th, 21st, and 22nd inst. It is necessary that he sh'd have a complete knowledge of pony and donkey racing; wheelbarrow, bag, cock, and peg racing; archery, singlestick, quoits, cricket, football, cocking, wrestling, bull and badger-baiting, dog-fighting, goose-riding, bumble-puppy, &c.
>
> In addition to the above qualifications, he must also be competent to decide in dipping, mumbling, jawing, grinning, whistling, jumping, jingling, skenning, smoking, scaling, knitting, bobbing, bowling, throwing, dancing, snuff taking, singing, pudding eating, &c.
>
> For further particulars apply to Mr. Farral of Bunbury; Mr. Vickers of Spurstow, or Mr. S. Mintcake of Nantwich.

June, 1808.

Although bear-baiting was not specifically mentioned in the advertisement, it is known that the sport was one of the most popular entertainments at Bunbury Wakes.

In 1635, Revd Edward Burghall, the Puritan schoolmaster of Bunbury Aldersey Grammar School, recorded:

> A multitude of people being set under the Church Yard Wall, at the south side of the Church in Bunbury, at the time of their Wakes, to see a Bearbait, the

Above: Wybunbury old church, *c.* 1760.

Left: Bunbury parish church.

wall suddenly fell down upon them, yet they were not hurt. They had the same disorder the year following and there happened the same disaster, and the same deliverance. Oh! the great patience of Almighty God.

There were many other wakes traditions that were customary in towns and villages across Cheshire. Since the beginning of the nineteenth century in Weaverham and Wybunbury, fig pies, known as 'Good neighbour pies', were baked and given to friends. Other pies were deliberately baked hard and rolled down Swan Bank in a unique wakes game. Sometimes the hard pies were hurled at passers-by from the church tower.

As time passed the wakes fell victim to brutality, cruelty and crime and, as might be expected, the authorities were somewhat relieved when they petered out, although some villages still hold a wakes day.

Location: CW6 9SH, CW5 7LY

The Plague in Cheshire

The 'sweating sickness' visited Chester in 1507, and then, in 1517, what is believed to have been the 'true plague' troubled the town. There was a recurrence of the 'sweating sickness' in Chester in 1551. When there was yet another visitation in 1558–59 there were even more deaths, but many fled the town to escape the pestilence. When the plague broke out again in 1574 the mayor, Sir John Savage, issued a number of strict regulations: houses with infection had to have an inscription stating, 'Lord have Mersey upon us.' Plague-stricken persons, or indeed anyone who were of their company, were not to leave their houses except without licence from the alderman of the ward. They were also required to carry in their hands a token to denote that they were infected. A curfew was imposed across the town, and infected people were strictly forbidden to go out during the hours of darkness. There were also restrictions regarding the passage of merchandise to and from the town. Additionally, plague-stricken houses sometimes had a wooden fence built around them. The plague reached a peak in 1603, when in excess of fifty people were dying every week. The epidemic was so bad that the Michaelmas fair that year had to be cancelled and, in an attempt to contain the outbreak, cabins were erected near to the waterside to house plague-stricken townsfolk, the upkeep being met by the town council.

There were often some bizarre and unexpected outcomes resulting from the plague. Philip Antrobus's house at Northwich was stricken with plague in 1576 and most of the inhabitants died as a direct result. All of the household linen, valued at 13s 4d (66p), was destroyed. Some sixteen years later a compensation claim was made through the courts.

The plague visited many other areas across the county including Malpas where, in 1625, a particularly virulent strain, it was believed, was brought to the town from London by Ralph Dawson of Bradley. Almost the whole of the Dawson family succumbed to the disease with Ralph's brother Richard actually digging his own grave. Knowing that he was soon to be consumed by the plague, and being of stout stature, he had his nephew put straw in the grave into which he then climbed, asking to be covered with clothes when he died. It is recorded in the parish register that 'because he was a strong man, and heavier than his said nephew and another wench were able to bury'.

There were also many acts of heroism. During the period when the plague was endemic in Congleton a nurse, colloquially known as 'Lancashire Bess' or 'Little Bess', steadfastly remained at her post, administering to the sick and needy.

At the height of the epidemic, between 22 June 1647 and 20 April 1648, 2,099 deaths from the plague were recorded in Chester. Other towns within the county also suffered many losses as a direct result of the plague, but the greatest number of deaths were in Chester itself. The demise of the plague in Cheshire coincided, broadly speaking, with its demise in London in 1666.

Location: Various locations

The Boggart in Gower Hey Wood

This legend tells of deceit, and moreover, from one who was a member of the medical fraternity.

Many years ago a very celebrated medic by the name of Dr Wylde lived in the vicinity of Hyde. He was an ancestor of the Thornelys, and was reputed to have an encyclopaedic knowledge relating to astrology and all things associated with astrological phenomena and beliefs. His reputation went before him and was such that people local to the area held him in awe and high esteem. In the early part of the eighteenth century, alarm and consternation spread throughout the locality because it had been reported that there was a boggart in Gower Hey Wood, and that weird and disturbing sounds could be heard coming from the wood during the hours of darkness. In fact, many residents were too afraid to venture into the woods when darkness fell, and others instructed their children not to go anywhere near to the woods, whatever the hour!

As the stories spread and the fears grew, a number of villagers decided that they needed the assistance of the good doctor, who, they believed, might be able to rid them of this terrible visitation, which was causing so much distress to the people living close to the wood. Accordingly, the doctor was approached and, much to

Gower Hey Mill, *c.* 1800.

Above: Walk through Gower Hey Wood.

Left: Gower Hey Wood.

everyone's relief, agreed to intercede on their behalf. Unbeknown to the villagers, he went into the wood the very next day, entering at a spot where he could detect the weird sound, a spot which no one else had dared approach. After some initial investigation, he soon ascertained that the so-called weird intermittent noise was actually being caused by two branches of an oak tree rubbing together when the wind blew in a certain direction. He chose not to inform people of his findings, but promptly returned home to fetch his hack saw. Without further ado he removed the offending branches and secreted them in his wood store.

Towards the end of the week many people in the village had observed that there were no noises coming from the wood. A deputation went to see the doctor who calmly announced that he had laid the spirit. After this revelation, the doctor's reputation for being a worker of magic became unequalled in the region, and for many years after that people believed in his powers, never having learnt the true facts of the mysterious boggart of the wood!

Location: SK14 5HU

The Stalybridge Bread Riots

In 1861 cotton workers in Stalybridge had little knowledge of the struggles that lay ahead of them. Indeed, many were of the belief that they might expect a rise in wages in the near future, but they were sorely mistaken; their masters, however, knew the true state of affairs.

In March that year many of the weavers staged a turnout seeking an advance on their wages, but news came of the outbreak of hostilities across the Atlantic, and all trade within the region became paralysed. At first mills went onto short time, but before long all working ceased and the mills became silent. By the winter of 1862/63 there were more than 7,000 in Stalybridge alone without gainful employment, and many more who were only partially employed. The situation deteriorated to such an extent that a national scheme of relief was established. It was estimated that at one point, three-quarters of all of the cotton operatives in Stalybridge were dependent upon the charity of others.

A committee was appointed to distribute relief, but differences soon emerged between them and the beneficiaries themselves as to how the relief should be distributed. As the situation deteriorated still further, members of the Relief

Caroline Street.

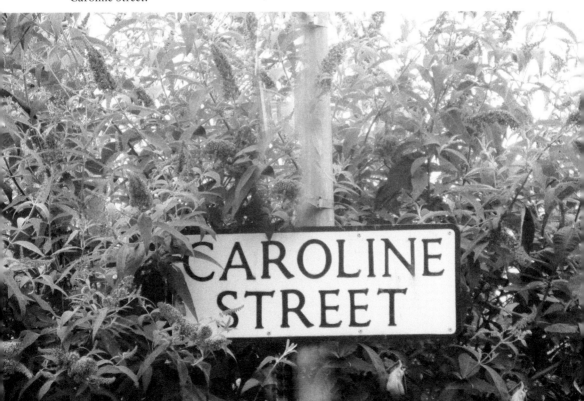

Committee took the decision to introduce a system of 'relief by ticket' instead of giving money directly. It was this decision that ultimately led to the 'Bread Riots'. The committee instructed that the tickets were to be presented at the local shops where goods to the amount on the face of the ticket would be supplied, but the tickets were so unpopular that organised resistance began, and on Friday 20 March 1863 the town witnessed one of its darkest days. By mid-afternoon a large crowd had gathered near to the entrance of Mr Bates's mill in Castle Street. Police were in attendance endeavouring to keep order, but the crowd was angry and, eventually, their anger spilled over and a stone was thrown, hitting one of the constables, who then attempted to arrest the person who had thrown it. This was met by a shower of missiles being hurled at the police, who, in turn, charged the mob. After what amounted to a pitched battle, the police retreated, and the crowd, now empowered, headed for Mr Bates's home on Cocker Hill where they wrought havoc. At the time Mr Bates's aged mother lay ill in bed upstairs. She died a little while later, although it was never proved to be as a result of the attack on the house. While this was happening, another group of rioters made their way to the relief stores, which were near to the Wellington Inn in Caroline Street, where they smashed windows and looted the building.

Some two hours after the rioting had first begun a troop of hussars arrived from Manchester. Then, working in conjunction with the police, they rounded up and arrested around eighty of the ringleaders, taking them to the Town Hall where they were read the Riot Act by David Harrison Esq., JP. The fact that twenty-nine of the arrested rioters were committed for trial at Chester caused further unrest in the town, but when a company of infantry arrived and marched through the streets with bayonets fixed, the crowd soon dispersed.

As a direct result of an intervention by the town's mayor, the ticket system was accepted for the time being on the understanding that, in the near future, the normal payment system would be reintroduced. Honour was satisfied on all sides.

Location: SK15 1PD (The Wellington Inn in Caroline Street has since been demolished.)

River Tame flowing near to Caroline Street.

The Haunted Farm at Godley

The farmhouse at Godley Green was stone-built and stood overlooking farmlands at Matley and Hattersley. It was always rumoured in these parts that the place was haunted. The legend arose because there was, reputedly, a treasure buried within the grounds of the farm and after the death of the witch-like old lady who was the last tenant of the farm, unable to rest in her grave, she wandered around the place as though searching for something that was lost. Over the years many different people have experienced some very different happenings. It has been reported, on more than one occasion, that in the dead of night doors have mysteriously opened, even when they had previously been locked, and footsteps of some unseen being have then been heard walking up the stairs and through various bedrooms. The doors have then been locked once again, just as mysteriously as when they were first opened. Other people have awaked in the

New Gates at Godley Green Farm.

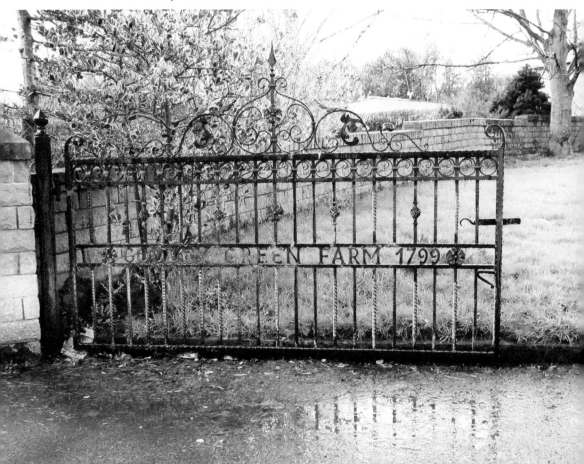

dead of night when their beds have been violently rocked and the bedclothes ripped off and deposited on the far side of the room. Still others have witnessed fire irons tumbling and dancing around the rooms, with pots and pans rattling and falling onto the floor and strange noises as though some invisible person was sweeping the floors.

In the earlier part of the nineteenth century the ghostly appearances became so frequent that the farmer and his family became inured to the presence, but still found the loss of sleep somewhat annoying. Although these visitations didn't bother the family, they were of some concern to occasional visitors. One evening, when the farmer's daughter was entertaining her betrothed, a mighty wind rushed through the house, and every door was wrenched wide open. Sensing that her suitor was a little afraid, the farmer's daughter sought to reassure him saying that it was only the old lady's ghost. With that, the young man seized his cap and ran out of the door, never to be seen in the house again! Five minutes later, all the doors were quietly and mysteriously closed, as though nothing had happened.

One farmhand, when seeing the ghost one night, thought that it was his mother come back to haunt him because he hadn't placed a suitable headstone on her grave! Although he continued to work at the farm, he never spent another night there, preferring to walk 8 miles to work every day.

Finally, the farmer asked the pastor of Hyde Chapel, Revd James Brooks, to perform the service of 'laying the boggart'. After spending a few nights reading verses from the Bible and uttering special prayers for driving evil spirits away, the boggart was partially 'laid', only returning at infrequent intervals.

However, the strangest manifestation occurred sometime between 1880 and 1890, when children visiting the house heard loud noises coming from one of the upstairs bedrooms. Summoning adult assistance from the fields around the farm, the mystery was soon answered when a rocking chair in a corner of the room was seen to be violently rocking backwards and forwards without anyone being sat in it. The rocking continued until the farmer's wife herself sat in the chair and stopped it. Later research by the farmer showed that one of the previous tenants had died in that very room while sitting on her favourite rocking chair.

Location: SK14 3BD (access via unadopted road is not recommended)

The Wizard of the Edge

There are many legends in and around the area of Alderley Edge. Perhaps one of the most famous is the tale of the Wizard of the Edge.

Many years ago there was a farmer who lived in Mobberley. He owned a milk-white mare, but he needed to sell it, so one fine day as the sun was just rising, he set off on his way to Macclesfield Fair. As he was approaching the elevated ridge of sandstone known as Alderley Edge, the horse suddenly stopped and refused, point blank, to move a single step further, no matter how much the farmer cajoled and pushed the wayward animal. The farmer then happened to notice an old man standing by the side of the road, sporting a white beard and attired in a long flowing robe. Seeing the farmer's plight, the old man walked over and offered his assistance, also offering to buy the horse, but, thinking that the offer was too low, the farmer declined and decided to carry on to Macclesfield. As he made to depart, the old man shouted after him, suggesting that if he didn't manage to sell the mare, then he would buy it from him on his return.

When the farmer reached the market, sure enough, everyone admired his horse, but nobody offered to buy it. Somewhat dejected, the farmer set off to return home. When he reached 'Thieves Hole' at Alderley Edge, he was once again met by the old man, who was smiling broadly. At this point, the farmer

Above: Alderley Edge.

Right: View over the Edge.

was feeling a little fearful, as was his horse, but the old man pacified them saying, 'Fear nothing'. He then once again offered to buy the horse, and this time the farmer was more receptive and readily agreed. Then, without entering into any further meaningful conversation, the old man merely said 'Follow me!' He then led the farmer past the Seven Firs and the Golden Gate. They continued walking by Saddle Boll and Stormy Point, where the old man stopped, and it was here that he struck, with a heavy blow from his staff, the sandstone rock. The rock split, revealing a pair of iron gates that opened as they approached. Behind the gates the farmer could see a deep cavern. On being invited to enter, he could see a huge wooden chest in the centre of the cave and laying around the chest a large number of sleeping men, together with their white horses. Seeing the farmer's look of incredulity, the old man then went on to explain the reason for the purchase: the horse of one of the sleeping knights was lame, so a replacement was needed in case the knight's services were required. When the farmer gave the reins of the horse to the old man, he was invited to delve into the chest and take as much coin as he could carry as a reward for selling his horse.

When the farmer left the cave to make his way home, he turned to bid farewell to the old man, but there was no sign of him. On his arrival home he told the story to his wife and family. They were intrigued and wanted to be taken to the place themselves, but when they made the journey a few days later there was nothing to be seen apart from the barren sandstone of the Edge.

Location: SK10 4UB

Above: Alderley Copper Mines.

Left: Wizard of the Edge pub.

'Souling' in Cheshire

One of Cheshire's lesser-known customs is that of 'souling'. The festival was held on All Souls' Day, the day after All Saints' Day, which is commemorated on 1 November. It is believed that the church custom first started as early as the tenth century. During the Middle Ages, it became the custom for people to walk around the villages, stopping at every street corner and ringing a handbell. The assembled company was then invited to join in prayers for all souls in Purgatory. Following impromptu prayers, everyone was asked to contribute towards paying for masses to be said for those in Purgatory. The custom continued for some time, but after the Reformation, instead of 'soulers' asking for money, they now requested food and drink.

On the festival day, and at a designated hour, people left their homes and made their way to church, where they remained in pious prayer all night. Meanwhile, the prepared feast was consumed by thieves who benefitted from the ancient religious custom. It would appear from this that the custom of preparing 'soul-cakes' and their subsequent consumption was not for the benefit of the 'soulers' themselves, but rather for the recipients of the feast. The cakes themselves were filled with various ingredients including ginger, nutmeg, allspice and cinnamon. Other ingredients such as raisins and currants were used when available. Before being placed in the oven, the cakes were marked with a cross, similar to today's hot cross buns, in order to signify that these were alms.

The custom of 'souling' was, until relatively recently, observed in many villages in and around Chester on the eve of All Souls' Day, when parties of children would parade around the streets singing verses from the old 'Souling Song'. In some areas of Cheshire, most notably Northwich and Tarporley, the 'soulers' were often accompanied by another person, who would follow behind carrying an imitation head of a horse, which would continuously snap its jaws. This variation of the custom was 'lifted' from the pagan custom of 'hodening', which was practised in Kent.

In 1891 Revd M. P. Holme of Tattenhall, Cheshire, was able to obtain the words to the traditional 'Souling Song':

> God bless the master of this house,
> The mistress also,
> And all the little children
> That round your table grow.
> Likewise young men and maidens,
> Your cattle and your store;

And all that dwells within your gates,
We wish you ten times more.

[Chorus, repeated after every verse]
A soul! a soul! a soul-cake!
Please good Missis, a soul-cake!
An apple, a pear, a plum, or a cherry,
Any good thing to make us all merry.
One for Peter, two for Paul
Three for Him who made us all.

Down into the cellar,
And see what you can find,
If the barrels are not empty,
We hope you will prove kind.
We hope you will prove kind,
With your apples and strong beer,
And we'll come no more a-souling
Till this time next year.

The lanes are very dirty,
My shoes are very thin,
I've got a little pocket
To put a penny in.
If you haven't got a penny,
A ha'penny will do;
If you haven't get a ha'penny,
It's God bless you.

The custom of 'souling' was also observed in other parts of Europe, and before the fifteenth century, many homes provided lavish entertainment on the eve of All Souls' Day, so that souls in Purgatory could revisit the scenes of their earlier labours.

Location: Throughout Cheshire

Chester's Eastgate Clock

The Eastgate Clock, as it is known, was erected on the bridge over Eastgate Street, the original entrance to the Roman fortress of Deva Victrix. Eastgate itself is medieval and was constructed in Norman times. The original structure was made from local sandstone and was very narrow in order to make it difficult to storm the gate by force. This structure has since been replaced as it restricted the flow of traffic into the city.

When discussions were first held as to how Chester should celebrate and commemorate Queen Victoria's Diamond Jubilee in 1897, the 1st Duke of Westminster suggested that the city should support Queen Victoria's Jubilee Institute of Nurses. Other suggestions included incorporating a clock into the Town Hall tower or erecting a statue of Queen Victoria in the Town Hall square.

A Jubilee Fund was opened and once a committee had been established, the project began to move forwards, raising a grand total of £1,800. It was decided that the funds that had been collected should be divided into three equal parts: one third would support a nursing scheme, one third would be for 'general rejoicing' and the remaining third would be used to design and build

Below left: Eastgate Clock from Eastgate Street.

Below right: Chester Eastgate, *c.* 1766.

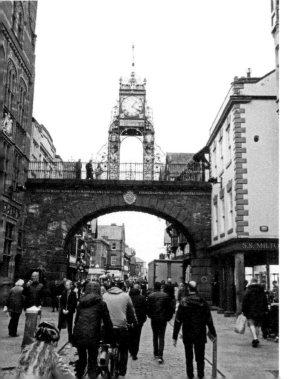

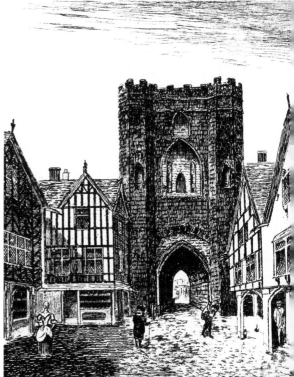

a clock tower to be erected on Eastgate. John Douglas, the eminent Cheshire architect, was invited to prepare suitable designs. His earlier designs favoured a stone clock, but these suggestions were rejected by the committee, who opted for one of his later designs, a light ironwork structure containing a clock. This design was approved in March 1897. A local solicitor and freeman of the city, Colonel Edward Evans-Lloyd, paid for the clock's faces and mechanism, and the subsequent maintenance of the clock was to be met by the City Corporation.

J. B. Joyce & Co. of Whitchurch, Shropshire, founded in 1690, designed and built the clock's mechanism and the clock itself, and, up until 1974, also supplied a technician to travel to Chester each week to wind it. The four dials of the clock are 4 feet 6 inches in diameter and were gas-lit when the clock was first unveiled. Since that time, the gas system has been replaced by a more efficient electrical mechanism, together with a battery-operated back-up system. Initially the clock kept accurate time by using a system of weights, but time regulation of the clock is now computer controlled. The cast ironwork on the clock was manufactured by the Coalbrookdale Iron Company, and the ironwork for the tower was made by the firm of James Swindley of Handbridge.

The Mayoress of Chester, accompanied by Miss Sybil Clarke, niece of Colonel Evans-Lloyd's, formally unveiled the clock at a civic ceremony that was performed on 27 May 1899, Queen Victoria's eightieth birthday.

Location: CH1 1LE

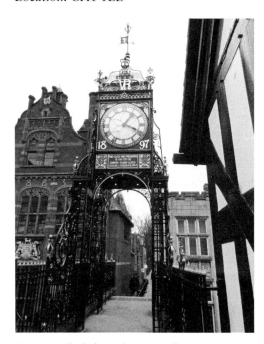

Eastgate Clock from the city walls. Eastgate, Chester, c. 1900.

Murder at Knutsford

In the early evening of Sunday 7 April 1901 Mary Jane Francis, who was employed by Mrs Speakman of Knutsford Heath, was walking in Mere Heath Lane when she discovered the body of a man lying in the road. She walked over to the body, but found that the man was dead, although the body was still warm.

Following extensive inquiries, the body was identified as that of John Bould, a vest maker of Knutsford who had been employed by Messrs Slater, tailors. After further examination, it was found that there was a total of five shots in the body. The police reported that there was no evidence of a struggle, and that the deceased had money in his pockets and was still wearing his watch and chain. However, because Bould was so well liked by his fellow workers, they found it difficult to suggest a motive for the murder.

Bould was described by his landlord as single, teetotal, a steady respectable man, and a member of the Roman Catholic Church.

The facts that could be determined were that Bould had left his lodgings at approximately ten minutes to seven, so he must have gone straight to the location where Mary Francis found his body just after seven o'clock. One salient piece of information that Mary did provide was that immediately before going over to the body, she had seen a man bending over the body of the deceased man, and, upon seeing her, the man ran away.

Above: Mereheath Lane.

Right: Mary Jane Francis's walk to Mereheath Lane.

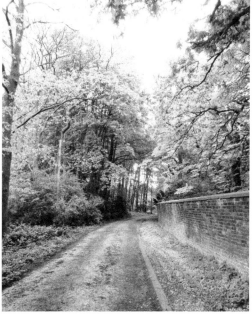

The post mortem, which was conducted by Dr Smith, found that the shots had been fired from a distance of around 3 feet, and there were also severe lacerations about his head, probably having been caused by blows from a hard instrument.

At the inquest, Mary said that when she arrived at the end of the lane she saw a man and a woman with a child; she did not know them. Later on, she saw the well-dressed man coming out of the field, but when he passed, she did not recall in which direction he went. Mary then went on to testify that she was then overtaken by three men on horseback, and one of them dismounted. The man had his horse tied to a railing and bade her good evening. He then caught her around the waist rather tightly; she repulsed him and screamed. After this incident, she set off towards home. It was then that she heard two loud reports. She commented to one of the men that somebody must be shooting birds on Sunday. Continuing with her testimony, Mary stated that when she arrived at the corner, she saw a man stooping over the man, and that he had his hand on the man's chest, but on seeing her he ran off. She then saw two men, George Toft and Hugh Daniels, walking towards her. The three of them went back to check that the man was dead. Daniels then went to report their discovery to the police.

John Bould's sister, Elizabeth Street, gave testimony to the effect that she thought that she knew who the assailant was, but she wasn't prepared to divulge this speculation under oath. She suggested that the murderer must have been familiar with guns in order to be able to shoot a man five times, and said that the police should focus their attention on finding somebody fitting that description.

A twenty-one-year-old man was tried for Bould's murder, but he was found not guilty.

Location: WA16 6AW

Along Mereheath Lane.

The Pepper Gate Elopement

Rauff (Ralph) Aldersey, an alderman of Chester, had a very beautiful daughter, Ellen, and, being a proud man conscious of social position, wanted a 'good marriage' for her. He'd actually chosen a very wealthy suitor for her, who, it transpired, was many years her senior. It was all too obvious that Ellen was not best pleased with this proposed marriage, and the situation became even more fraught between father and daughter when Alderman Aldersey discovered that Ellen was in love with a poor draper called Rauff Iaman. He immediately forbade her to meet with this totally unsuitable young man, but Ellen had other ideas!

As a punishment, Ellen was only allowed to meet with other young women of her class in order to get some daily exercise. The group often played ball on a green near to Pepper Gate, and one day, when the ball was thrown particularly high, it went over the city walls; Ellen immediately volunteered to retrieve it. Ellen's lover was waiting just outside, together with two well-bred horses, and within seconds they were galloping off down Souter's Lane, across the Dee Bridge and on into Wales. The alarm wasn't raised until the couple were well on their way.

After her elopement, it was recorded in the assembly book of the city that she 'was married by an unlawful minister to one Rauff Iaman, draper, without the consent and goodwill of any other kinsfolk and friends, to their great heviness and grief, and contrary to any good civile order'.

Below left: Pepper Gate.

Below right: Pepper Gate, *c.* 1850.

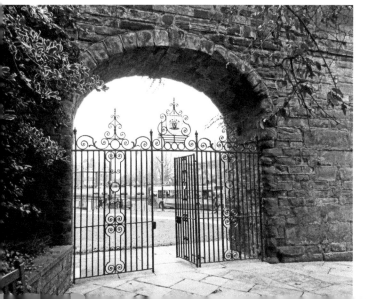

Alderman Aldersey had been so incensed when he'd heard the news of his daughter's elopement that he persuaded the council to issue an order for the Pepper Gate (also known as Wolfe Gate or New Gate) to be opened during daylight hours, but only to pedestrians, and then closed completely at night. The order read: 'for divers good causes, a certain gate or passage through the walls, called Wolfe-gate or New-gate, shall forthwith be stopped and fenced substancially and that no passage to be suffered in the nyght and the same to be opened in the day'.

Pepper Gate, originally built so that the townsfolk of Chester could gain access to St John's Church, which was just outside of the city walls, had been one of the main gateways through the city wall since the thirteenth century, and this order caused untold inconvenience to spice merchants who needed the gate to be open in order to give them constant passage to and from the nearby Pepper Street. Their dark humour soon gave rise to a popular colloquialism in and around Chester: 'When the daughter is stolen, shut the Pepper Gate', being the local equivalent of another well-known adage relating to 'shutting the door after the horse has bolted'.

Not being able to enjoy their life together in England, the couple went abroad shortly after their marriage. Rauff prospered, and as a direct result of his undoubted success, he was knighted by Queen Elizabeth before returning to Chester as Lord Lacey.

Location: CH1 1DF

Pepper Gate from the city walls.

The Muzzled Bear of Brereton

The tale of the muzzled bear of Brereton is still told throughout the county of Cheshire and even beyond. One evening, when Sir William Brereton was enjoying his dinner, his valet entered the room where Sir William was dining. The valet soon became aware that he had incurred the wrath of Sir William and fled upstairs, but Sir William was so enraged that he followed the servant and, in his uncontrollable rage, murdered him. Later, when his sense of equilibrium had been restored, Sir William was repentant of the grave crime that he had committed, and was also conscious of the probable consequences of his action. He immediately made haste to London to plead his case before the king, assuming that he would be able, in some way, to mitigate the punishment for his dastardly deed. When admitted into the king's presence, Sir William fell on his knees and pleaded for clemency, but the king, having been apprised of the circumstances of the case, refused him a royal pardon. He did, however, offer Sir William a chance to save his life. Sir William was to be allowed three days in which to invent a muzzle that would, effectively, muzzle a bear. After three days of being incarcerated in the Tower of London, Sir William was taken to a room into which a bear was then let loose. Somehow, Sir William was able to throw the muzzle over the bear's head

Brereton Hall.

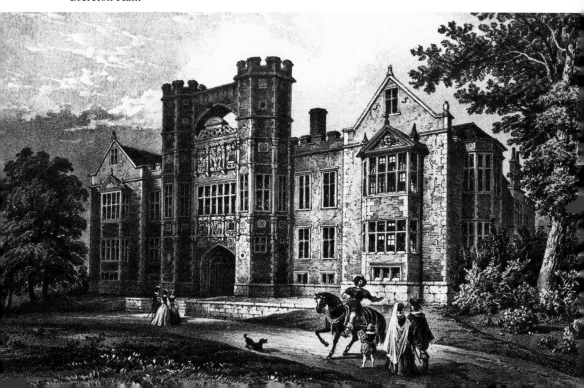

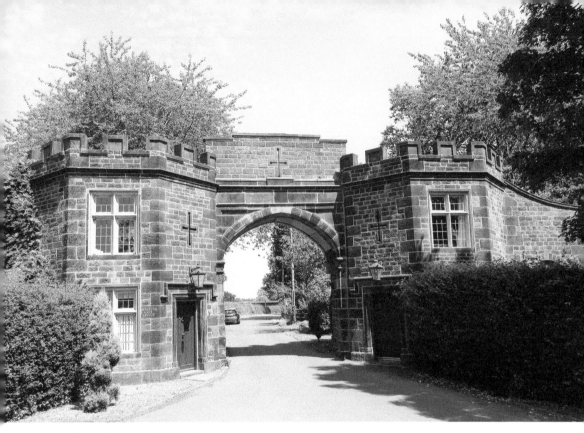

Above: Brereton Hall Lodge.

Below: Brereton Hall, *c.* 1880.

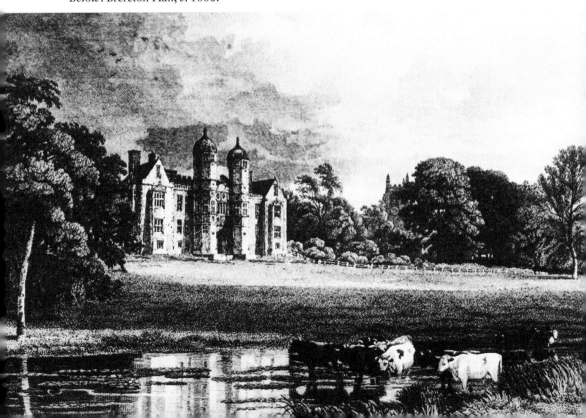

Above: The Bears Head Inn.

Right: The main entrance to Brereton Hall.

and secure it, thus avoiding being killed by the bear. At the end of the ordeal, Sir William was given his freedom and was allowed to return to his home. Shortly after that gruesome event, the muzzled bear became the emblem of the Brereton's. The family motto is '*Opitulante Deo*', which means 'With God as my helper'.

As was the case in many other areas of the country, bear-baiting was a particularly popular sport at that time. It was customary for the bear to wear a leather muzzle in order to prevent it from biting the dog, which had an integral role in the sport, and it also helped, to some extent, the bear from being bitten by the dog.

The sport was so popular that in the nearby town of Congleton, just 5 miles distant from Brereton, where cockfighting and bear-baiting were both popular sports, the town's bear died just a few days before the town's annual wakes. Fortuitously, at the time, a fund had been started to buy a new bible for the town's church, but, when news of the bear's death became known, a sum of 16s (80p) was taken from the fund in order to buy a new bear, giving rise to the rhyme:

> Congleton rare,
> Congleton rare.
> Sold the Church Bible
> To buy a new bear.

Location: CW11 1RZ, CW11 1RS

Simnel Sunday

Lent was always seen as a very long fast, only broken at mid-Lent by the tradition of Mothering Sunday, which was observed in many parts of Cheshire by the eating of Simnel cakes. 'Simblins' or simnels derive their name from the Latin word for fine flour (hence semolina), and are said to have been mentioned as early as 1042 in the Chronicles of Winchester.

Mothering Sunday itself is widely thought to have its origins in the old custom of making offerings at the local mother church, although others believed that it dated from an older heathen custom whereby, in Rome, offerings were made to the mother of the gods on the Ides of March. However, the most popularly accepted explanation is that it was a custom whereby offerings were taken to mothers, and the day can still be observed as the anniversary of the return of the prodigal son, when it was said, 'I will arise and go to my Father', and to commemorate the killing of the fatted calf, veal is often served for dinner, with perhaps a bit of simnel, where the centuries-old verse was repeated:

I'll to thee a simnel bring
'Gainst thou go'st a mothering,
So that when she blesseth thee,
Half that blessing thou'lt give me.

Another tradition observed at the end of the Lenten period was the eating of carlin or carling peas, although it must be acknowledged that the custom was more widely observed in Lancashire than in Cheshire. Carling peas, variously called maple, partridge, or grey peas, were grown in eastern counties and harvested immediately before Easter. The peas were first boiled before being gently fried in butter. Salt and pepper was then added to the fried peas so that they became savoury, and the carling peas were then consumed with dry biscuits known as cracklings or cracknels. Carling Sunday was, traditionally, the fifth Sunday in Lent, the next Sunday after Simnel or Mothering Sunday. As the old rhyme says:

Carl Sunday, carl away,
Palm Sunday, Easter Day.

'Carl away' was said to mean that the peas should then be eaten throughout the week leading up to Palm Sunday.

Location: Throughout Cheshire

Northwich Salt Mines

The small town of Northwich stands on the banks of the River Weaver, and over the years there has been a significant amount of subsidence to the buildings in the town, and the bed of the Weaver itself has sunk. The reason for these changes is because the town and the surrounding neighbourhood have been built on soil that is riddled with watercourses. In turn, they became saline as a result of flowing over solid masses of salt. This action caused the rock to disintegrate, and finally the crust of earth itself settled.

The Romans were credited with working both the brine springs and the salt mines during their occupation. Then, after years of neglect, salt rocks were rediscovered on the outskirts of Northwich in or around 1670 by miners who were searching for coal deposits.

The geology at Northwich is such that the first bed of rock salt is found separated from a second and deeper one by a bed of clay. Both saline masses are between 90 and 100 feet, which, in itself, demonstrates the richness of the formation.

When the mines were back in production, the method of reaching the mine bottom was by way of a large barrel-like 'lift', having a circumference of approximately 4 feet. When working at its full capacity, the barrel could transport three or four men to the mine floor. The barrel itself was suspended on a heavy gauge steel chain. The depth of the shaft was approximately 130 feet below ground level. The only lighting in the shaft was via candles, which were held in a miner's candlestick, a lump of soft clay that enabled the candle to be affixed to the shaft wall. Once prepared, the salt was excavated with the aid of pick and

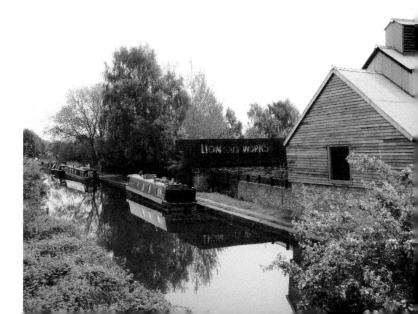

Lion Salt Works, Northwich.

wedge or gunpowder. With only hand tools available, a party of fifty men would be expected to extract upwards of fifteen hundred tons of raw salt in a normal working week, and for this their daily wage was 3s 6d (around 17½p). Because their wages were far in excess of other working men in the region and the air in the salt mines was dry and salubrious, it excited thirst and appetite. The miners were given to much drinking, arguing that it was 'the devil in their throats'. One of the reasons why miners received such high wages was because of the many major accidents that were a regular occurrence down the mines, especially when subterranean springs dissolved the pillars on which the various parts of the shaft were supported. Many miners lost their lives in such disasters. The ponies and donkeys that were used underground were taken down the mine when young, and only came to the surface again when it was time for them to be killed.

A great many women were employed in the Worcestershire salt works, but in order to work effectively, a state of semi-nudity was required. This was not thought to be conducive in Cheshire as it was considered to be altogether incompatible with feelings of delicacy. Women were not allowed underground in the Cheshire salt mines, although on certain occasions this rule was relaxed. There was a custom observed at major festivals, such as Christmastide and Whitsuntide, whereby the whole of the chamber of the mine was lighted with as many as a thousand candles, festooning the mine floor with light. At these times it was traditional for the miners' womenfolk to join them on the mine bottom, where bands provided music to accompany the dancing and general merrymaking.

Location: CW9 6ES

Chimney of Lion Salt Works.

The Postal Houses of Stockport

There were many so-called postal houses in and around the Stockport area, one of the most popular being The Warren Bulkeley Arms. Every alternate morning, at five o'clock sharp, the *Regulator* departed for London, returning the following afternoon at three o'clock and taking passengers up as far as Manchester. Also, every morning at six o'clock the *Despatch* left the Bulkeley taking passengers to Liverpool.

At the bottom of the Hillgate there was The Plough Inn, which was kept by Mr Walter Hickman. Coaches for Sheffield started from here at half past ten in the morning and returned the following day just after noon, often taking passengers up to Manchester. The *Telegraph* also left from The Plough at four o'clock in the afternoon, taking passengers bound for Manchester, returning at half past four the following afternoon before departing for London.

Other coaches, such as the *Silk Worm*, which started from Congleton, also took passengers to Manchester, as did the *Royal Macclesfield*, which started from The Plough at eight o'clock in the morning, and on its return at half past five the same afternoon, took up passengers bound for Macclesfield.

The *Independent Potter* started from The Plough Inn and carried passengers, every day, to Manchester, leaving at half-past twelve and returning on the same afternoon at a quarter past three. It then carried on to the Potteries. Also leaving from The Plough was the *Express*, which left for Birmingham every morning, returning the same afternoon before carrying on to Manchester. The *Duke of*

Stockport, *c.* 1860.

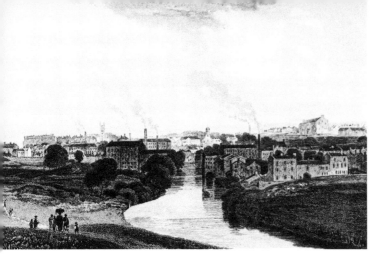

Stockport, *c.* 1820.

Devonshire left at half past three in the afternoon, taking passengers for Buxton. Another coach, the *Champion M*, left at seven o'clock every morning with passengers bound for Nottingham. It returned at half past three in the afternoon, its final destination being Manchester. One of the most famous teams travelling between Stockport and Manchester at that time was the team owned by Messrs Edmund and Richard Sykes. Instead of horses between the shafts, the Sykes's harnessed a huge bull, which, on good days, could do the work of several horses, but the bull was not always as compliant as horses, breaking loose on a number of occasions but, fortunately, never doing any serious damage!

In addition to the numerous coaches that went up to Manchester, there was also a luxury boat service that sailed from the Navigation Bridge. The service was primarily designed to transport cotton masters attending the Manchester market. The boat was fitted to the highest standards – the main saloon was beautifully furnished with crimson cushioned seats. The boat sailed along at a moderate pace, and for the first few miles businessmen would be cosseted in luxury and able to enjoy the journey and the countryside. However, before reaching Manchester, the boat had to navigate a number of locks that, in themselves, took quite some considerable time to pass through. The passengers were eventually deposited at Bank Top. However pleasant the boat trip itself was, there was a downside at the end of the journey, when coaches vied with one another to take the business men to their final destination.

Towards the end of the day, workers sometimes repaired to the Unicorn Inn, but, due to a paucity of both money and glasses, they were often forced to 'club together' for their refreshments. On such occasions, around two or three quarts of ale would be poured into the 'black jack'. The vessel was then passed around so that everybody got their fair share of drink. Anyone drinking the whole contents of a black jack in one attempt was considered to be a fine drinker.

Farmers in outlying villages often brought their produce to market, and to compensate for the long journeys, which many of them had had to make, the Rose & Crown was allowed to stay open day and night for the duration of the market. The privilege was much abused and the licence was ultimately withdrawn!

Location: Area around SK1 1XR

The Legend of Beeston Castle

Ranulf de Blundeville, 6th Earl of Chester, was a staunch supporter and favourite of King John, and, because of his loyalty, was rewarded with titles, castles and land across England. After the king's death, when Ranulf returned from the Fifth Crusade in 1220, he found that Hubert de Burgh, the king's viceroy, was in the process of confiscating lands from English nobles in order to constrain their hold on political power. Sensing this imminent development, and feeling the need to shore up his position, Ranulf decided to build a mighty castle – Beeston. Construction started in 1226, but Ranulf died in 1232 before building work had been completed.

According to a document that dates from the sixteenth century, it is alleged that a significant fortune was lodged in one of the castle's wells by Richard II immediately before he vacated Chester and crossed to Ireland in 1399. It is believed that the king hid his personal fortune here, which included gold coins, a gold quadrant in a leather case, a helmet belonging to St George and various

Beeston Castle, *c.* 1850.

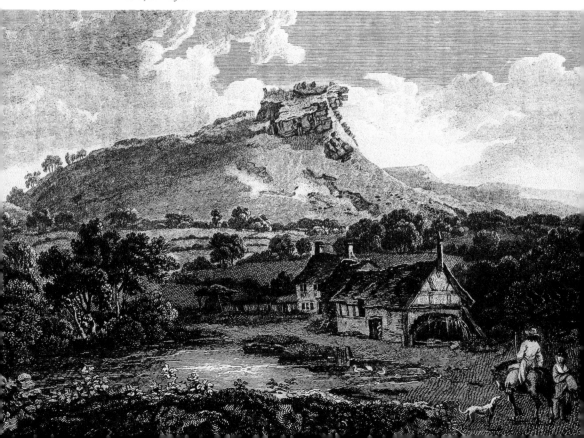

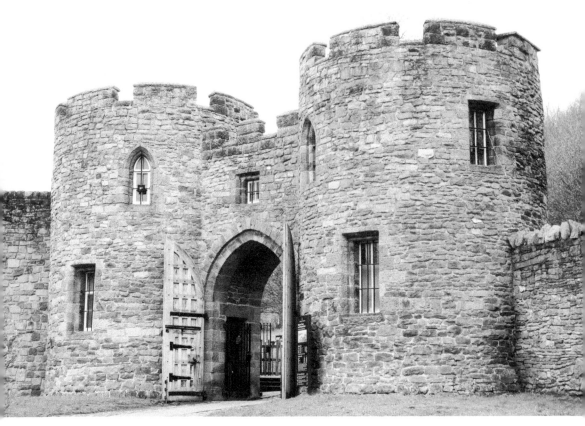

Outer keep at Beeston Castle.

other brooches and jewellery. Unfortunately, on his return from Ireland, the king was taken prisoner and removed to Flint Castle by forces acting on behalf of Henry Bolingbroke, the Duke of Lancaster and later to become Henry IV. The garrison at Beeston surrendered and the treasure was never seen again, many believing that it had been plundered by Henry Bolingbroke, although there is a school of thought that considers that the treasure is still lodged somewhere in the castle itself. Other documentation, written in Norman French, suggests that the treasure was hidden in Holt Castle, Wrexham, in order to mislead people into thinking that the treasure was in Beeston. Another authenticated document states that the treasure was reclaimed by Henry IV sometime during the fifteenth century.

The castle played a significant part in the Civil War. A Parliamentarian force of between 200 and 300 men was established at Beeston sometime in February 1643, but in the early hours of 13 December 1643, the Royalist Captain Thomas Sandford, together with eight men, scaled the walls and entered the castle. Once in, there were more Royalists waiting outside of the gate; the castle was surrendered and the Parliamentarians were allowed to leave, with dignity, the following day. Later, in November 1644, because of the Parliamentary siege of Chester, it became necessary to mitigate the threat posed by the Royalist

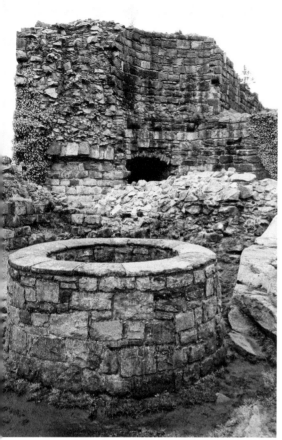

Above left: The well with the hidden treasure!

Above right: The commanding position of Beeston Castle.

Below: Beeston Castle from the north-west, *c.* 1890.

Beeston Castle, *c.* 1870.

garrison at Beeston. Cattle were seized from the area surrounding the castle by Parliamentary troops, and a siege ensued. There then followed a twelve-month Parliamentary siege of the castle, but after the king and his troops were heavily defeated at the Battle of Rowton Heath on 24 September 1645, it became futile for the Royalists to continue to hold out. Beeston surrendered on 15 November 1645. It has been reported that due to the desperate shortage of provisions during the siege, the Royalist defenders were forced to eat cats.

Upon the surrender of the castle, the then parliament ordered it be slighted, whereby the castle's defensive outposts were intentionally destroyed in order to prevent any recurrent uprisings. This was also the fate that befell many other English castles at that time.

Later, in the eighteenth century, much of the castle's stonework was used for various building projects in Cheshire.

Location: CW6 9TX

The Murder of Mary Malpas

Mary Malpas was a servant at Doddington Park near Nantwich, working for Henry Davison, Esq. Late in the evening of Sunday 28 June 1835, the lady of the house, Mrs Davison, was awoken by Mary, who told her mistress that she had been brought news that her mother was dangerously ill, and that she needed to return home. Soon after Mary left, Mrs Davison went downstairs to check that everything was secure. She found that the outside door was locked and that the key was missing; she assumed that Mary had taken it so that she could get back in when she returned.

The following morning, a ladder was discovered immediately below the room where Mary slept. There was speculation as to the reason why it was there. A little later, the body of a young woman was found in Chapel Field, Hunsterton. It was Mary Malpas. It was thought that the likely perpetrator of this heinous crime was Thomas Bagguley, as, shortly after the young woman's body had been discovered, the body of a man was found hanging some distance away. The obvious conclusion was that Bagguley had enticed Mary away from the house on the pretext of her mother being ill, but when the virtuous Mary refused his advances, he killed her. Then, being full of remorse, he committed suicide.

Doddington Hall, *c.* 1850.

Doddington Hall.

Bagguley, who lived over at Walgherton, was also employed by Mr Davidson. As a fifty-year-old married man, he was known to be of a quiet demeanour, honest and hardworking, and it was this apparent contradiction that caused so much consternation, especially as it was not thought that there was any intimacy between himself and Mary.

At the inquest Mrs Davison testified that Mary Malpas was her maid, and that on the evening of 28 June, Mary had retired to bed at around half-past nine. Mrs Davison continued, stating that at around half past twelve on the same night, she was awoken by a knock on her bedroom door. It was Mary, who said, 'Mistress, shall I go and see my mother, who is taken dangerously ill, and likely to be dead.' She gave permission for Mary to return to her parent's home. Mrs Davison said that after hearing Mary leave the house, she went downstairs to lock the front door, but it was already locked. She assumed that Mary had taken the key so that she could get in on her return. However, the next morning when she went downstairs, both the inner and outer doors were wide open.

Simeon Davis, a servant at Doddington Farm, testified that at five o'clock on the morning of 29 June, he and another labourer, Ralph Latham, were walking through Chapel Field to fetch the cows in for milking when they saw a woman's body on the ground; her petticoats appeared much disordered, and it was clear that she was dead. They returned to their master's house where they told of the tragedy.

Two surgeons, Mr John Twemlow and Mr Edward Barker, testified that Mary Malpas had been assaulted and then strangled.

Right: Wybunbury Church.

Below: St Margaret's Church, Betley.

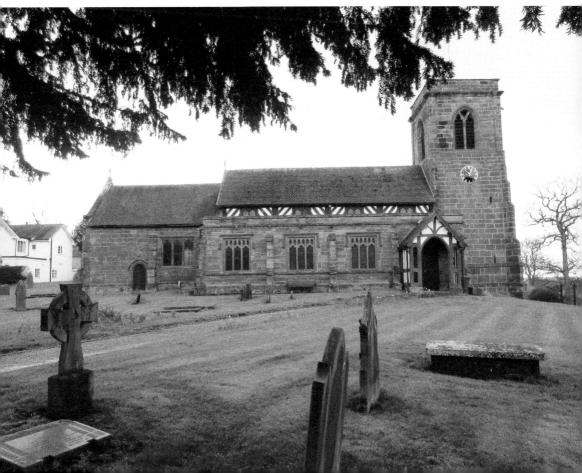

Ann Malpas, Mary's mother, testified that she was not at all unwell on the day in question, and had not sent anyone to the Davison house to say otherwise.

John Shuker, another farmworker, testified that he had agreed to meet Thomas Bagguley on that morning, but he had not turned up. When Shuker later went to his house, he was told by Bagguley's wife that he had not been home all night. Returning to the Davison's, Shuker was asked to suckle the calves. Upon entering the hay crib he saw Bagguley hanging, quite dead. He also testified that Bagguley was in possession of the key to the front door of the Davison house.

The jury's verdict stated: 'Thomas Bagguley, deceased, for having in the night of Sunday, 28th June, feloniously and wilfully destroyed the deceased Mary Malpas, by strangulation.' Mary Malpas was buried at St Margaret's, Betley.

At the inquest of Thomas Bagguley, a verdict of felo de se was returned: 'That the deceased feloniously and wilfully destroyed himself by suspending himself to a ladder, with a small cord, on the morning of Monday, 29th June.' Thomas Bagguley was buried in Wybunbury at midnight on 1 July 1835, which was the practice at that time for people who committed suicide.

The ghost of Thomas Bagguley is said to haunt Doddington Cottage at Bridgemere.

Location: CW3 9AX, CW5 7LY, CW5 7PU

The Superstitious Farmers of Cheshire

Farmers, scattered across Cheshire, were at one time known for holding many superstitions with regard to their livestock, but there were also customs associated with their crops. For instance, in order to ensure a plentiful harvest, parsley should be planted on Good Friday and shallots should be planted on the shortest day of the year and pulled on the longest.

It was often recommended by doctors that, in order to aid recovery, milk should be drunk that had been taken from a red cow. As a classic case of gender confusion, there was always said to be a 'master' in every herd of cows. This 'ringleader of mischief' would often break down hedges to gain access to neighbouring fields, which might contain turnips or other succulent vegetables. Another example of gender confusion occurred when a hen was heard to be crowing like a cock. This was seen as a sign of bad luck, and the only remedy was for the hen to be killed straightaway. Similarly, it would always bring good luck if an odd number of eggs were placed under a sitting hen.

Folklore, which is still believed in many parts, said that when all the cows in the herd were seen lying down in a field then the weather was certain to be wet. It was also thought that a good indication of the day's weather was to check the colour of frogs, but the skill lay in the interpretation! Similarly, stormy weather was forecast when pigs were seen with straw in their mouths; hence the expression 'pigs can see the wind!'

There were other customs relating to the behaviour of pigs: whenever sows farrowed, their diet was supplemented with hot toast and lard in the belief that this would prevent the pig from eating any of the litter; and when it was slaughtering time, pigs were killed when the moon was waxing, as they were deemed to be heavier at this time.

There were many superstitions concerning the keeping of bees. Whenever there was a death on the farm, especially if it was the farmer himself, then the bees must be informed, otherwise it was certain that they would swarm from the hives. Whenever bees did swarm it was a common practice to clatter a frying pan or tin, causing the bees to settle or 'knit.' It was also a firm belief that bees should never be bought, but either begged or borrowed. If the only alternative was to buy them, then they should be paid for in gold, or else exchanged for a suckling pig. Failure here would mean that the bees would not be lucky for their keeper.

Whenever there was illness around the farmstead, especially if there were children living on the farm, having a donkey with a stripe on its shoulder, known as a cross, was particularly fortuitous, as a strand of the hair could ward off any signs of whooping cough, a common and often deadly complaint among youngsters. A few strands of the hair were sewn into a piece of flannel or muslin and worn round the neck of the patient, although in some areas of the county, it was more common to chop up the hair very finely and eat it between thick slices of bread spread with lashings of Cheshire butter! In general, evil spirits were kept away from the farm and its animals by nailing a horseshoe to the stable door.

Location: Throughout Cheshire

Gentleman Edward Higgins

Gentleman Edward Higgins first moved to Knutsford in or around 1756. However, long before that time he had been tried in Worcester on a charge of sheep stealing, but due to lack of evidence, he had been acquitted. A period of two years elapsed before Higgins once again found himself in court, this time on a charge of breaking into a local house. He was tried on 14 May and duly sentenced to transportation for a period of seven years. He was removed to Maryland on the 'Frisby'.

Not finding deportation to his liking, less than three months after arriving Higgins staged an audacious robbery, removing a large amount of money from the home of a wealthy merchant. He immediately purchased a passage on a liner bound for England. On his return, Higgins settled in Manchester, but soon moved to Knutsford where he bought a very imposing property, No. 19 Gaskell Avenue, otherwise known as Cann Office House. It was in Knutsford that he met Katherine Birtles, whom he married on 21 April 1757. They had five children. Higgins

Higgins's home at No. 19 Gaskell Avenue, Knutsford.

continued to masquerade as a country gentleman of means, mixing with the upper echelons of Knutsford's elite, and, although spending time outside of the area, it was widely assumed that he was acting in his capacity as a wealthy landowner.

From the knowledge that he gained by attending various social functions, Higgins soon became acquainted with the layout of several grand properties. Later, he was able to return and plunder the property. When staying at the Egerton's in Oulton Park, Higgins 'lifted' a jewelled snuff box, which he then proceeded to hide in the grounds of the house. The following morning when the theft was discovered, Higgins led the investigation into the theft, and even had all of the servants rooms searched, but to no avail.

One night when walking along the Rows in Chester, Higgins saw a ladder propped against a property in Stanley Street. Stepping up to investigate, he saw a young woman dressed in fine clothes and wearing some exquisite jewellery, Higgins entered her bedroom chamber when he was sure that she would be asleep and removed the jewellery from the dressing table. Unfortunately, while in the process of 'lifting' the items the young lady stirred, only to say in her half sleep: 'Oh, Mary, you know how tired I am; can't you put things straight in the morning?' On another occasion while visiting a neighbour's house, Higgins noticed the stunning diamonds that Lady Warburton was wearing. Determined to relieve her of them he followed her carriage, but on approaching was dumbfounded when she said 'Good-night Mr. Higgins; why did you leave the ball so early?'

In truth Higgins acquired much of his wealth from his activities as a highwayman, waylaying coaches on the turnpike road between Knutsford and Chester.

Higgins broke into a house in Bristol, but during the robbery also murdered both the occupant and her servant. He then went on to break into another

Plaque outside of Edward Higgins's home.

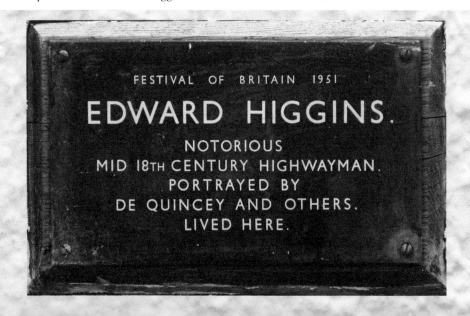

FESTIVAL OF BRITAIN 1951

EDWARD HIGGINS.

NOTORIOUS
MID 18TH CENTURY HIGHWAYMAN.
PORTRAYED BY
DE QUINCEY AND OTHERS.
LIVED HERE.

Town centre, Knutsford, *c.* 1880.

property in Gloucester. For this robbery he was actually arrested in his own home, but managed to escape. He decamped to French-Hay near Bristol, where he lived for some time, once again leading the life of a country gentleman. On one of his many sorties, he was caught when he broke into Lady Maud's house at West Mead. He was soon identified as an escaped prisoner, tried and sentenced to death. Even then the resourceful Higgins attempted to escape justice by having an accomplice forge a letter granting him a reprieve, but the ruse failed and he was executed on Saturday 7 November 1767. Upon hearing of his fate, Higgins had written a note to his wife and family, wherein he declared, 'I beg you will have compassion on my poor disconsolate widow and fatherless infants, as undoubtedly you will hear my widow upbraided with my past misconduct. I beg you will vindicate her as not being guilty of knowing about my villainy.'

Soon after Higgins's body was taken down from the scaffold, it was seen that there was still a pulse! It was left to a young medical student to end Higgins's life.

Location: WA16 0DA

The Cheshire Doctoress

Bridget Bostock lived in the village of Church Coppenhall, a parish in the Hundred of Nantwich that lies around 5 miles north-east of Nantwich itself. Bridget was known to have a remarkable capacity for healing, and soon became known locally as the Cheshire Doctoress, or, more disparagingly, as either the Cheshire Pythoness or the White Witch of Coppenhall, whereas, in truth, she was actually little more than a faith healer.

Her acknowledged skills first received some wider recognition when letters appeared in the columns of the *Gentleman's Magazine* of September 1748. The letters alluded to her remarkable skills. One letter, written from Nantwich on 28 August 1748, made reference to curing the blind, the deaf, the lame of all sorts, the rheumatic, 'the King's evil' or scrofula, hysteric fits, falling fits, shortness of breath, dropsy, palsy, leprosy, cancers, and, in short, almost everything except

Coppenhall parish church.

the so-called French disease – syphilis, which she would not deign to go anywhere near! Bostock herself was brought up by a very respectable family. Another letter stated: 'There is risen up in this country a great doctoress, an old woman, who is resorted to by people of all ranks and degrees to be cur'd of all diseases. She lives four miles from hence, and has been in this great fame about two months. She has several hundreds of patients in a day out of all the country round for 30 miles.' Indeed, the doctoress was so busy – on occasions there were upwards of 600 people waiting to see her – that it became necessary to have a man 'keeping the door', only allowing access to five or six people at any one time. Towards the end of the day, Bridget often became weak, not breaking her fast until she had seen every person who had been waiting. While administering to the sick, Bridget, whose age was estimated at anything between sixty-four and seventy, continued to keep house for 'old Bostock'. She dressed very plainly and never took any monetary reward for performing her doctoring, much to the chagrin of doctors in the locality.

Revd William Harding, who was curate of Coppenhall church, spoke very highly of her and her undoubted skills, noting that she was a regular worshipper at his church. Revd Harding and his wife, Elizabeth, had seven children, one of whom was lame. Bridget had cured the son's lameness when all the other doctors that had been consulted had not been able to successfully treat the ailment.

Bridget's powers became so well known that an eccentric Welch nobleman, Sir John Pryce, 5th Baronet of Newton, Montgomeryshire, wrote to her in December 1748. His third wife, Lady Eleanor Pryce, had recently died and the distraught nobleman asked for Bridget's prayers in the vain hope that Eleanor might be restored to life. Sir John even had a coach sent up from Wales so that he and the Cheshire Doctoress could pray together.

On one occasion a woman from Liverpool, Mrs Gradwell, came for a consultation, wanting a cure for her blindness – she left, having had her sight restored!

Location: CW1 3TN

Easter Customs of Cheshire

There were many old customs held throughout Cheshire and neighbouring counties that marked the season of Eastertide. Many of these traditions and customs are now obsolete, but some still survive in remoter parts of the county.

In Ashton-under-Lyne and Dukinfield children paraded through the district holding a real or imitation bird's nest in their hands while chanting:

> Pace-egg! pace-egg!
> Other egg or haup'ny.

However, this was an abbreviated form of a longer petition that asked for:

> An egg, bacon, cheese, or an apple,
> Or any good thing that will make us merry,
> And pray you, good dame, an Easter egg.

The pace-egg was a tradition that was observed throughout many northern counties. The gift of a pace-egg was often a welcome addition to a child's diet, but, more often than not, they were not seen as articles of food, but rather as playthings. Rolling pace-eggs downhill was one of the recognised amusements of childhood on Easter Monday in many areas of Cheshire. The word 'pace' takes its derivation from the name of the Paschal Feast.

Another tradition was the so-called custom of 'lifting', which was neither very pleasant nor particularly decent, but survived in some parts of Cheshire until relatively recently. The practice was retained as a form of annoyance or merely as horseplay, long after the original significance of 'lifting' had been forgotten, for it was as far back as 1225 when seven of the ladies of honour of the queen lifted Edward I. The king rewarded them with a gift of £14 for performing this ceremony. 'Lifting' was originally performed to emulate the Saviour's Resurrection on Easter Day. Traditionally, men 'lifted' women on Easter Monday, and women 'lifted' men on the following day. In the latter years of the tradition, women often viewed the custom as a money earner, whereby small groups, 'the lifters', joined hands across each other's wrists and made an impromptu throne on which was placed the person to be 'lifted'. He was then elevated two or three times, and even carried for a little distance, but his return to the ground could be much less ceremonious. For the payment of a small fee, the unfortunate man being 'lifted' could be returned to ground more genteelly. The payment could be anything from 1s to a kiss, dependent upon who it was being 'lifted'.

The custom was widely discouraged, but at Eastertide in 1883 magistrates at Neston had an unusual case brought before them involving three men who, allegedly, had presented themselves at the house of the prosecutor, at Heswall. They had calmly informed him that they had come to 'lift' his wife. Upon hearing this, the prosecutor immediately told them to go away or he would kick them out, as he would not allow anyone to take such liberties. The defendants, by way of mitigation, informed the bench that they were only endeavouring to carry out an old Cheshire custom. The magistrates' ruling was that they had acted most improperly and must apologise to the lady in question and also to her husband. It was also directed that they must pay the costs of the hearing.

Location: Throughout Cheshire

The Tragedy at Over Cotton Mill

At around five o'clock on the afternoon of Tuesday 27 October 1874, fire broke out at Over Cotton Mill. Volunteer fire brigades from Witton, Middlewich and Tarporley attended, but the first on the scene took almost two hours to arrive, by which time much of the mill was damaged beyond repair. The firefighters then concentrated on saving nearby properties, but their work was hampered by brickwork from the mill collapsing around them.

The cotton mill, newly built five years previously, was owned by Messrs Abraham Haigh & Sons. Over 300 people were employed at the mill, many having moved down from Lancashire. Mr James Haigh, head of the family firm, was away on business at the time, but returned as firemen were still striving to contain the blaze.

St John's Church.

As the flames took hold, Harriet Whitehurst together with her three-month-old son, Thomas and thirteen-year-old daughter Margaret became trapped on the fourth floor of the six-storey building. At first they had tried to escape down the staircase but were overcome by the smoke. Looking out of the window, Mrs Whitehurst saw a large water tank below. She instructed her daughter to jump into the tank; she landed safely. She then threw her son down and jumped directly after him. They crashed to the pavement in full view of the stunned onlookers. Then, just minutes later, they witnessed another woman being burned to death, her escape being thwarted as her clothing became entangled in a rail.

When the fire was finally extinguished, firemen from Tarporley recovered the charred remains of five more bodies, bringing the death toll to eight. It was not possible to positively identify the eighth victim, but neighbours suggested that it was Mr John Timperley, a married man who lived in Factory Street.

An inquest into the tragedy was held at the Wheatsheaf on Friday 30 October 1874. Before hearing any evidence the coroner's jury viewed the charred remains of the cotton mill.

Mr Bullock one of eighteen men working in the spinning room, said that he saw a spark, which had been caused by friction coming from the machinery, and it was that spark that had started the fire. Together with other spinners, he had tried to smother the flames, but the fire spread so rapidly that they had to make their escape. He stated that there were no appliances to fight the fire. He declared that there was no agreed fire drill, and that there should have been dozens of water buckets throughout the mill, but none were to be found in the spinning room. The coroner agreed that friction from a pulley most probably ignited loose cotton and sparked the tragedy.

Margaret Whitehurst was one of the main witnesses. She had to identify the remains of her mother and brother. She then testified that the three of them had tried to escape by a staircase, but finding that impossible, her mother had told her to jump into the water tank below. Her mother threw the baby out of the window and then jumped herself. They both fell to their deaths. She stated that she had worked at the factory since she was eight.

Spinning master John Kay stated that when the fire began he went to the top of the building to fetch water, but was overcome by smoke inhalation. He then fell through three flights of stairs. On seeing that there was no way down, he decided to jump through a window into the same water tank that had saved the life of Margaret Whitehurst.

Returning a verdict of accidental death on all the victims, the coroner, Mr Churton, stated that no one was to blame but suggested that it would have been wise for the mill owner to have kept a small portable engine at the mill.

The eight people who perished were buried in a common grave at St John's Church, Over.

Location: CW7 2LY

The Hoylake Lifeboat Disaster of 1906

Established in 1803, the Hoylake lifeboat station is one of Britain's oldest and, because of the town's geographical position together with the prevailing winds in that area, it also makes it one of the most difficult stations to man, but the gallant men of the station are counted as being among some of the most skilled and experienced in the country. However, the gales in the Irish Sea that raged on Thursday 15 November 1906 were, by far, the worst in living memory, with ships being tossed like corks on the waves. The night will long be remembered by the people of Hoylake.

The lifeboat at Hoylake, the Shannon class 13-06 RNLB *Edmund Hawthorn Micklewood*.

It was at two minutes past eight in the evening that the coxswain superintendent of the station, Mr Thomas Dodd, and Mr Charles, the secretary at the station, saw distress signals coming from the Rock Channel, just over a mile from the shore. In a well-practiced procedure, they immediately fired a rocket and, although there was great peril on the seas that night, the lifeboat's voluntary crew all arrived at the lifeboat station in a very short space of time.

Minutes later, the *Hannah Fawcett Bennett*, the last Hoylake lifeboat to use oars and sails, was being drawn by horses across the sands to the water's edge, and at precisely 8.28, the lifeboat was launched with a crew of fifteen men rowing two abreast. As it transpired, not all of the volunteers were regular crew of the Hoylake boat, as many of the regular crew were on the Hilbre lifeboat that had been called out to give assistance to a vessel in distress on the East Salisbury Bank of the River Dee. One of the volunteers making his first rescue as a Hoylake lifeboat man was twenty-three-year-old local fisherman John Isaac Roberts.

Even though the storm was at its height, every one of the volunteers knew that their efforts could well help to save the lives of the sailors in distress. The lifeboat made steady progress towards the strickened vessel, but just before they were able to make contact, the lifeboat was struck by a mountainous wave and, for a while, chaos ensued. The station's secretary, Mr Charles, was a member of the crew on that fateful night, and he testified that the force of the wave had sent many of the crew sprawling all over the boat, and many sustained minor injuries. Thomas Morris, another member of the crew, said that he saw Roberts washed overboard, but in the turmoil, it was some little time before he was able to alert coxswain Dodd as to what had occurred. By the time that the alarm had been raised, the lifeboat had drifted some way from where Roberts had been lost. Although a thorough search was made, nothing more was seen of the volunteer lifeboatman and the crew was forced to renew their efforts to save the three crew members on the vessel in distress, the *Swift of Runcorn*.

Upon reaching the distressed vessel, the lifeboat's crew exhorted the three men from the *Swift* to abandon ship and come on to the lifeboat, but the *Swift* was so heavily damaged that the three men did not think it safe to make the leap over to the lifeboat and, try as they might, the lifeboat's crew could not persuade them. Eventually, after several hours and much reluctance, Coxswain Dodd took the decision to return to the Hoylake station. On returning to the lifeboat station, the true extent of the damage sustained during the rescue was revealed.

When the tide ebbed, all three men from the *Swift* were able to walk ashore after enduring an ordeal that had lasted over seven hours.

The body of John Isaac Roberts was recovered the following morning on the Moreton embankment. An examination showed that the probable cause of death was severe injuries to the head.

Location: CH47 3AL

Whippings in Altrincham Market Place

There are many tales of punishments metered out to miscreants in Altrincham. One such penalty that was common in the area was reserved for women of so-called 'light character' – a euphemism for women assumed to be prostitutes or women of 'light behaviour and loose morals'. The punishment was also handed down to women who had been guilty of spreading scandal. In order to comply with the stated terms of the penance, the condemned woman was covered with a white sheet, kept in the church for such occasions, and then marched up and down the aisles until she had been purged of her offence.

A similar but harsher form of punishment was inflicted by placing a scold's bridle, or branks bridle, over the offender's head. This 'iron mask' was used as a form of torture and public humiliation. Once in place, the wearer neither being able to talk nor eat, would be led through town to humiliate them and show that they had committed an offence. However, before this particular form of punishment became popular, a more ancient form of punishment was the cucking

Visit of the Prince of Wales to Altrincham in the jubilee year.

Altrincham Market Place, 1858.

stool; indeed, there was a field in Altrincham known as 'Cuckstool field'. This form of punishment was first made reference to in the in Domesday Book as '*cathedra stercoris*'. It was a punishment chiefly reserved for cheating bakers, brewers and other petty offenders. The offender was led to the stool and then immersed such that the 'stercore', or stinking water covered both their head and ears. The 'brydle for a curste queane' was fixed in the mouth of the delinquent, and tied behind with ribbons. Mr Mort, a resident of Altrincham, tells of an old woman who abused her more peaceable neighbours, especially the inoffensive people living on either side of her own property. Although they implored her to modify her behaviour, all their efforts were treated with distain by the old woman. Ultimately she was ordered to be bridled and led through the town, but when the instrument was fixed to her, she stubbornly refused to walk. The authorities were determined to make an example of her so, in order to carry out the punishment, she was tipped into a barrow and unceremoniously wheeled around the town and the marketplace, ending back at her own home. It is recorded that she was accompanied by a crowd of guffawing townsfolk. She didn't repeat the offence!

Whipping was another popular punishment handed down for trivial offences; the spectacle of miscreants being publicly humiliated was a common sight, especially as, more often than not, the punishment was inflicted on the unfortunate offenders on market days. On one particular occasion, two accomplices were due to be whipped, but after the first man had taken his punishment, he begged to receive his conspirator's lashes as well, as he was sure that his accomplice would not be able to bear the punishment – an act of true gallantry.

Above: Altrincham Market Place today.

Left: Inside Altrincham Market Place today.

Public executions were common, even for relatively minor offences. On 25 September 1819 Samuel Hooley and John Johnson were executed for a burglary at Bowdon. Early in the following year Thomas Miller was executed, also for a burglary at Bowdon. Over a decade later, a man by the name of Henshaw was executed for poaching near Altrincham.

Location: WA14 1PF

Luddites at Stalybridge

When power looms and other mechanical equipment were first introduced to the mills, there was much opposition from the workforce. Mills in the area kept their doors locked throughout day and night for fear of newly installed machinery being vandalised. Many of the mills were more like fortified garrisons rather than manufactories. Disgruntled workers often adopted violent tactics in order to thwart the will of the owners. The derogatory name given to the supposed worker's leader was 'King Lud' and his acolytes became known as 'Luddites'.

When the Luddites became an organised group, they insisted that upon being accepted as a member – or 'twisted in' – newly initiated members must swear the following oath of allegiance:

> I, of my own voluntary will, do declare and swear that I will never reveal to any person or persons under the canopy of Heaven the names of any of the persons composing the secret committee, either by word, deed, or sign, or by address, marks, or complexion, or by any other thing that may lead to the discovery of the same, under penalty of being put out of the world by the first brother whom I would meet, and of having my name and character blotted out of existence. And I do further swear that I will use my utmost endeavours to punish with death any traitor or traitors who may rise up against us, though he should fly to the verge of existence. So help me God to keep this oath inviolable.

Everyone who joined that society, whether they were tradesmen or merely youths in their teens, had to swear the oath of allegiance.

The statements of intent were not solely confined to the Luddites themselves. Mill owners and managers had placards printed and prominently displayed upon mill walls. A typical placard declared:

> The villain who takes this oath deprives himself of that liberty which is the birthright of all Britons, deprives himself of trial by jury, and binds himself the willing slave of the vilest and most blood-thirsty assassins and incendiaries...

Whilst another stated:

> this oath is an offence against man, as it defeats the purpose of human justice, and enables the assassin and murderer to escape with impunity, ...who have taken this oath weakly and wickedly suppose that it supersedes all moral and

religious obligations, and think that such a compact which they have entered into releases them from any duty which they owe to God, their King, and their country.

The situation deteriorated so rapidly that manufacturers in the area soon realised that military intervention would be the only way to solve the worsening crisis. A Scottish regiment stationed in the south of England was detailed to march to the neighbourhood in order to quell the worsening situation. It was Captain Raines who led the soldiers into the district, making their headquarters the Roe Cross Inn. After the riots had been successfully quelled, Captain Raines was presented with a piece of plate as a token of thanks for services rendered.

The so-called 'reign of terror' of the Luddites first began in November 1811, and was endemic throughout the cotton district. At the height of the riots, gangs of armed workpeople roamed from place to place, destroying property and machinery, and even threatening life. Power looms were smashed and mills were set on fire. There were further violent riots and disturbances at Stalybridge on the 20 April 1812. Rioters were arrested in large numbers, tried and convicted, many later perishing on the scaffold.

Location: In the area of SK14 6SD

The Old Woman of Delamere Forest

In the summer of 1815 rumours were spread about a strange woman who had come to live in Delamere Forest. She brought the following letter to Vale Royal:

Madame, Madame, Thumley,
At Vale Royal, Cheshire.

Most Honerth, Highborn lady, My Lady Thumley,

As I have heard, that I am at the present tim, at your property, namely at the Oakmare, – We are latly, comen out of Germany, ware I lost my Husbund. As I came into England, I vind Rents so high, that I do not know how to do for to live, without Charity, as the same way as most of the people live abroad, so I am gone about, to seek some waste ground, for then I can live, and provide for myself, for I have a little to make a small beginning, but Halas! I vind, that all the Commons are verbid. Now I am at rest, and this place I am able to live, if I may be there, but I do not mean to make myself a Parish, for I never intent to submyt to Parish keping, for I belong to a foring Chapel, in London, but I may yet do for myself, if I am permyted. Therefore, I humbly beg, Noble Lady, you would not denie me this favour, to stop here for a few weeks, till I write up to London, for I cannot pay for Lorging. I humbly beg that your honour may send some of your trusty servants to enquire, and to see ware we are.

 We can we shall not trouble any body, for any thing, nor hurt, nor destroy any thing, rather protect the remanes of the Trees, most noble Lady, I humbly begg, deny my not a little rest, at this peaceable place – I am,

Your most obligint and humble Stranger,

Maria Hollingsworth.
Oakmere, 17th July, 1815.

It was clear that she had fallen on hard times. She said that she had been born in West Friesland, where her father was a Lutheran clergyman. Later in life she had married an English soldier of the 22nd Regiment, but her husband fell at Bergen op Zoom. Being a widow with two children, she travelled to England where she was given a small pension from Queen Charlotte while her son became a bound apprentice in Hanover. So that she and her daughter could live without incurring

Above: Oak Mere.

Left: The Old Woman of Delamere Forest.

undue expense, she bought a cart and donkey in which they travelled around the countryside, seeking somewhere to settle. Unable to find anywhere suitable, she resolved to take a passage to America and make a new life. On her way to Liverpool she passed through Delamere Forest and came across a lake, Oak Mere. She decided to stop for a few days so that she could wash her clothes but, after finding that the land was 'extra-parochial', she decided to make Oakmere her permanent residence where she soon settled in.

As time passed and the forest became enclosed, a number of cottages were built in the vicinity of Oak Mere, and she started to give lessons to her neighbour's children, but differences between her and her neighbours soon brought the lessons to an end. At about the same time, she received a letter from her son saying that he was returning from Hanover.

One evening she saw him walking towards her, but instead of finding his way to her home, he went to a neighbour's house to make some sort of enquiry.

Nothing happened for a while, but then she saw two men carrying what looked to be a very heavy sack towards the mere. The sack was slung into the water, but when it didn't sink, it was fished out and the neighbours returned home. The two men came out sometime later, this time carrying two spades and the heavy sack. The old woman feared that they were about to bury her son's body. She followed, but lost sight of them. When she did locate them again, they were returning to their cottage with an empty sack. Local men helped to search for the body but their searches proved fruitless. Sometime later a body was found at Marbury. She declared that it was indeed the body of her son. This conclusion did not satisfy the magistrate and he decided to make further investigations. Mrs Hollingsworth assisted in the investigation, but her testimony was found to be false; her son was alive and well and still living in Germany. Following correspondence, her son returned to England, much to the displeasure of his mother, as her story of his death was totally discredited.

Mrs Hollingsworth ended her days living in a Dutch Almshouse and her daughter went into service.

Location: CW8 2ES

The shores of Oak Mere.

Blossom in the village of Oakmere.

The Winsford Waterman's Strike

Towards the end of the nineteenth century, Winsford, at the centre of the Cheshire salt industry, bore the brunt of the continuing depression in the salt trade. The poverty being experienced by workers in the region was so great that in order to help to alleviate their hardship, salt companies were establishing relief funds and coal was being freely distributed to destitute families. At this time many of the companies, working under the collective of the Salt Union, were not producing any salt, and workers were employed for less than three days a week.

The watermen who crewed the vessels owned by the Salt Union went on strike, and salt workers, being in sympathy with them, refused to load river vessels. In order to overcome this 'local difficulty', the Salt Union sent a contingent of 100 non-union men, brought in from Liverpool, to replace them, which had the effect of inflaming the situation. The non-unionised men were housed at the Meadow Bank Works. The path from the works led down a small hill and then passed through an archway. On reaching the other side of the tunnel, they were met with a barrage of stones and bricks being thrown at them. The police officers at the works charged the offenders, but were overwhelmed by the constant assault from the missiles. One man, Samuel Maddocks, was taken into custody and handcuffed, although his comrades did attempt to free him. Then, when the

Salt Union Works at Winsford.

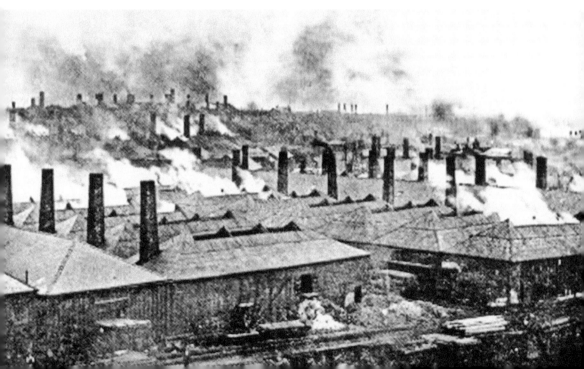

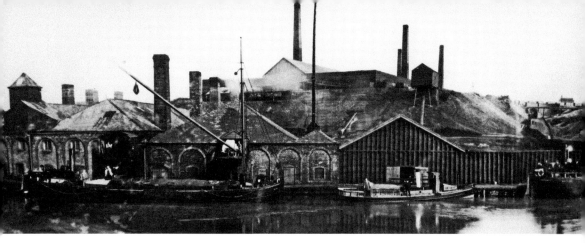

Above: The salt works in 1892.

Right: Police reinforcements.

imported workers arrived at Newbridge Lock they resolutely refused to move any further. They demanded to be transported back to Liverpool. Even given the exhortations of senior police officers, they were adamant; their labour was at an end.

During this time Samuel Maddocks was being taken to Winsford, but, meeting with hostile crowds along their way, the police took the prudent step of crossing the river and landing at Bostock's works. As the prisoner was being dragged ashore, the police were faced with another hostile crowd. They managed to gain entrance into the central offices, which, in turn, sparked another shower of stones being thrown through the office windows. Officers inside the building decided to charge at the crowd. Armed with their truncheons, the police ran from the

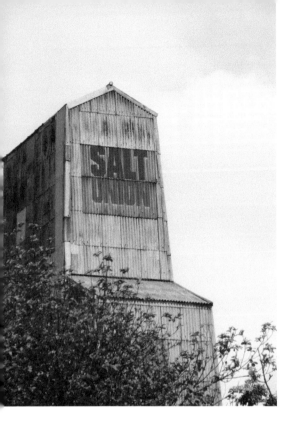

Above: Newbridge Swing Bridge.

Left: Salt Union Works.

building, causing most of the hostile crowd to turn and run for cover. There were injuries inflicted to both police and pickets.

The following morning the Chief Constable sent police reinforcements into the town, and the management of the Salt Union issued a statement to the effect that they would be taking legal action against the ringleaders at a later date, and also stated that the safety of their workforce was of paramount importance, and if the police couldn't contain the disturbance, then they would seek military intervention. Most of the striking workforce viewed the proceedings with a degree of curiosity and scepticism, taking the view that more non-union men were on their way. In late afternoon a train stopped on the line directly facing the police. The striking salt makers called upon the newly arrived men from Liverpool to act as men and refuse to work. After a short stand-off, around half of the men left the train and joined the police. Striking workers urged them to go back, and many heeded the call.

A special train transported the 100-strong squadron of hussars from Manchester to Winsford, and a local magistrate addressed the crowd making them aware of the gravity of the situation. He implored them to return to their homes, stating that, otherwise, he would have to read the Riot Act, which meant that the military could then use live ammunition to disperse the crowd. The police also maintained a watching brief, but there were no further disturbances that night.

Location: CW7 2PN

The Headless Woman of Tarvin

During the time of the Civil War, Cromwell's Parliamentary soldiers were committed to wiping out the strength of the Royalists in and around the city of Chester. Because of the strategic importance of the nearby village of Tarvin, both sides fighting the war were intent on garrisoning the village. In fact, at some point during the confrontation, the village was garrisoned by either one side or the other, and, perhaps more alarming, it was also attacked by both sides! Ultimately, in September 1644, the Parliamentarians – Roundheads – garrisoned the village with enough troops to render it almost impregnable. The village remained in the hands of the Parliamentarians until the end of the war. Before that time, however, one prominent Royalist, Squire Joseph Hockenhull, lived at Hockenhull Hall, lying to the south-west of the village of Tarvin. Being warned that Parliamentary soldiers were on their way to the hall, Squire Hockenhull hid the family's treasures and then fled together with his wife and family, leaving a distant relative, Grace Trigg, to guard the treasure. More popular versions of the legend maintain that Grace was a trusted maid servant.

When the hall was overrun by Parliamentary forces, Grace, then in her twenties, was found hiding in the cellars. She was captured and, in an attempt to find out where the treasures were hidden, was subjected to prolonged and painful torture. Miraculously, she managed to free herself from her captives and took flight, heading towards the 'Roman Bridges' at the end of Platts Lane. Being pursued by a group of around twenty soldiers, Grace was recaptured before arriving there. In the resulting struggle, she was beheaded. This act was, apparently, unintended. It is believed that the soldiers were about to slit Grace's

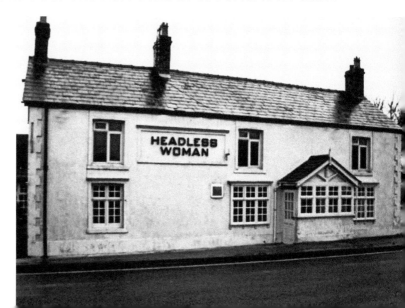

The old Headless
Woman Inn.

Above: Hockenhull Hall.

Left: The old Roman Packhorse Bridge.

Packhorse Bridge.

throat, but they applied such force that her head became detached from her body. Another version of the legend maintains that Grace was dragged from the cellars up to the attic and subjected to the most brutal torturing. It was important that the soldiers found the treasure, as the silver could then be melted down and used to mint the much-needed coinage to pay for the war effort. When Grace refused to submit to their force, she was beheaded and then taken to the 'Roman Bridges' where her body was dumped in the River Gowy.

On occasions the ghost of Grace Trigg can still be seen walking with her head under her arm. She walks along the old path from Hockenhull Hall towards the area where the public house known as The Headless Woman once stood.

The so-called 'Roman Bridges' were indeed originally built by the Romans when the road that they were building from Chester (Deva) to Northwich (Condate) crossed the River Gowy south-west of Tarvin. The original wooden bridges are no longer standing, but there is still a crossing at that point, and the Packhorse Bridge, which was constructed during the latter part of the fifteenth century, is still known as the 'Roman Bridges'.

Location: CH3 8LE

The Witches Trial of 1656

In 1604 James I of England (James VI of Scotland), who had personally led witch hunts in Scotland, signed the Witchcraft Act. There then followed an intense period of witch hunting, resulting in trials that were invariably followed by the imprisonment, torturing, flogging, drowning or hanging of the accused. As was the case in many places, parishes in Cheshire were no exception to the witch hunts that were taking place across the country at the time.

At the Michaelmas Assizes held at Chester on Monday 6 October 1656, two women from Ranowe (Rainow), Ellen Beech and Anne Osboston, and another woman from Eaton near Chester, Anne Thornton, were brought before the court, by Richard Golborne, Constable of Chester Castle. All three women pleaded not guilty. Another woman from Ranowe, Elizabeth Johnson, was also sent for trial, but she was acquitted because the evidence against her was deemed to be insufficient.

When brought before the magistrates and jury, it was alleged that Ellen Beech, the wife of John Beech, collier of Ranowe, did on 12 September 1651,

St Mary's-on-the-Hill, c. 1840.

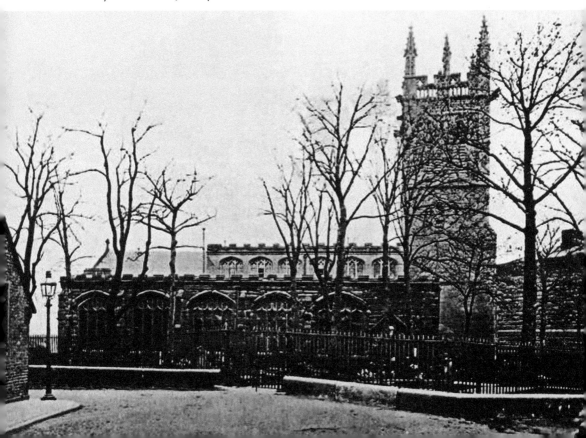

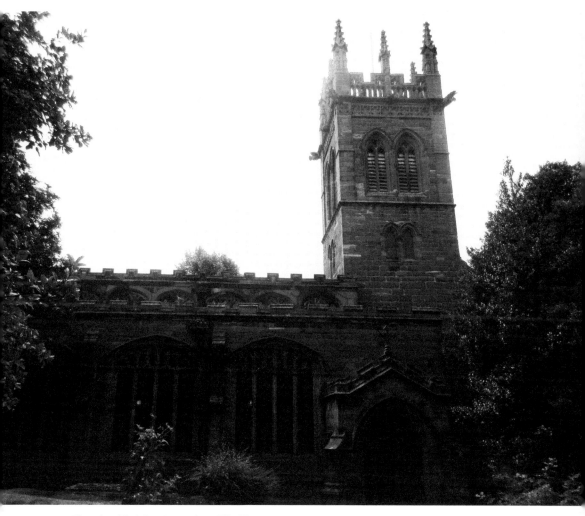

Church of St Mary's-on-the-Hill, Chester.

and on divers other days as well before as after, at Ranowe, exercise and practise the 'Invocacon and conjuracon' of evil and wicked spirits, 'and consulted and covenanted with, entertayned, imployed, ffedd and rewarded certayn evill and wicked spirits'. Evidence was presented that alleged that Ellen Beech did exercise certain 'Witchcrafts' upon Elizabeth Cowper. It was stated that, as a direct result, Elizabeth Cowper fell ill on the 12 September and died upon the 20th of the same month.

Anne Osboston, wife of James Osboston, husbandman of Ranowe, was tried as a witch. It was alleged, and later proved to the satisfaction of the court, 'that Anne Osboston, wife of James Osboston, did on the 12th day of September, 1651, practise certain wicked and divellish acts upon John Steenson, husbandman of Ranowe, which caused his death on the 20th of September.' Also, on the

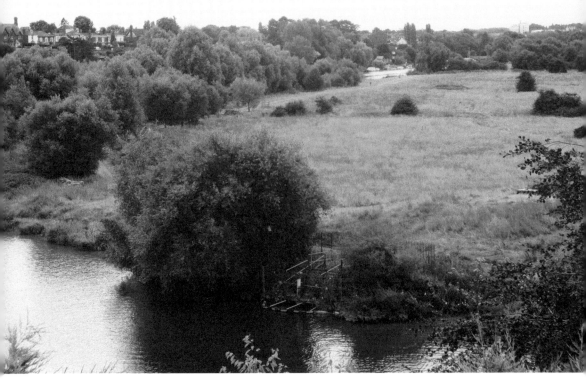

View from Gallows Hill.

30 November 1651, 'the said Anne Osboston used enchantments upon Anthony Booth of Macclesfield, thereby causing his death on the 1st April the following year'. Then, on the 20 November 1653, the same Anne Osboston, 'exercised certayn artes and incantacons on Barbara Pott, late wife of John Pott of Ranowe, whereby she too died from their effects on the 20th January the following year'. The final evidence brought before the court alleged that, on the 17 July 1655, 'the said Anne Osboston practised sorceries on one John Pott, late of Ranowe'. He became ill and died on 5 August.

Ann Thornton, who lived at Eaton near Chester, was accused of 'not having God before her eyes and practised certain devilish and wicked acts and incantations on one Daniel Finchett, son of Ralph Finchett of Eccleston, being an infant of three days, whereupon he languished and died'.

At the end of the trial, the jury found the three women to be guilty. The women were sentenced to be hanged severally by their necks. John Bradshaw, on behalf of the Lord Protector, endorsed this recommendation. The three were hanged at Gallows Hill, Boughton. In the Church of St. Mary's-on-the-Hill at Chester, the register for 1656 reads: 'Three witches hanged at Michaelmas Assizes, buried in the corner by the Castle Ditch in Churchyard 8th October.'

Location: CH1 2DW (St Mary's-on-the-Hill), SK10 5XF (Rainow)

Tales of Marbury

There was a hall at Marbury as far back as the reign of Henry III, and perhaps even before that time. The hall was the main residence of the Merbury (Marbury) family until 1684 when Richard Marbury, the then owner, died. Richard's sisters Katherine Marbury, Elizabeth Thacker and Mary Woods then administered the estate until Richard Savage, 4th Earl Rivers of Rock Savage, bought the hall and estate in 1708. The hall later passed to the Hon. Richard Barry MP, and then to his nephew, James Hugh Smith-Barry. Following several changes of ownership, the hall fell into disrepair and was finally demolished in January 1969.

Over the years many tales and legends relating to Marbury Hall have been told, but perhaps the two most well-known stories tell of the Marbury Dunne (sometimes spelled Marbury Dun) and the Marbury Lady.

There are several different legends that tell of the Marbury Dunne. One popular legend is set at the time of the Jacobite rebellions, when James, 4th Earl of Barrymore and a Jacobite supporter, was suspected of treason. One of his acquaintances, reading the situation, dispatched a messenger to warn him that he was soon to be arrested. The horse, Marbury Dunne, made such good time that the earl was able to hide any incriminating evidence against him and thus avoid arrest. Unfortunately, the horse itself was not so lucky. Upon reaching the hall, exhausted, the horse drank deeply from the nearby Budworth Mere and promptly died.

Marbury.

Above: Marbury Hall, *c.* 1840.

Below: Marbury Hall.

Evidence of the Marbury estate at Marbury Country Park.

Another popular but perhaps more fanciful story relating to the horse recounts that when Lord Barrymore was to marry a lady from London, he bought his bride-to-be a thoroughbred horse called Dunne Mare. Barrymore further promised that the horse would be at Marbury Hall in time for the wedding ceremony. Some days later the horse set off from London at sunrise and arrived exhausted at sunset. After jubilantly greeting the horse's arrival, the bride-to-be had the horse led to Marbury Mere to drink, but the shock of the cold water arrested the horse's heart and it collapsed and died. Heartbroken and inconsolable, Lady Barrymore died shortly after. It is thought that the horse was buried in the grounds of the hall, and the inscription on the gravestone read:

Here lies the Marbury Dunne
The fastest horse that ever run
Clothed in a linen sheet
With silver shoes upon her feet

The Smith-Barry family of Marbury Hall also enjoyed breeding and racing horses and, after returning from his Grand Tour, James Hugh Smith-Barry continued to follow this passion. One of his favourite watering holes was called The Spinner,

Spinner and
Bergamot.

an inn named after a local spinning loom that was located between Pickmere and
Wincham. Sir Hugh even named one of his most successful horses Spinner after
the pub. In 1762 Spinner won every race she entered, and in 1764 went on to win
the Ladies' Plate in Scarborough before retiring to stud. Sir Hugh decided to buy
the pub and renamed it 'The Spinner and Bergamot' as a tribute to another one of
his most successful horses, Burgamotte, that won the Chester Cup in 1794.

In addition to his equine interests, James Hugh Smith-Barry was also an
obsessive collector of works of art, and during the 1770s spent much of his time
touring Europe and the Middle East acquiring more art treasures for the hall. It
was during his time away that he met and fell in love with a beautiful Egyptian
woman. There was talk of marriage, but that never materialised. At length, James
departed for England, leaving behind his heartbroken lover. Months passed, but
the Egyptian lady could not get James out of her mind. She opted to take decisive
action and followed him to England! On a cold winter's night she found herself
approaching Marbury Hall, hoping to be reunited with her lover. However, since
his return to England, James had met Mrs Ann Tanner, with whom he enjoyed
an amorous relationship. Being confronted with a somewhat difficult situation,
James resolved the issue by employing his former lover as a housekeeper. It is
thought that while being employed at the hall their illicit relationship continued,
but came to an abrupt end when she died on one of the hall's staircases. Whether
this was due to natural causes was never established. Suffice it to say, her
body was removed to Great Budworth Church, but later returned to the hall,
as ghostly events started to occur there. There is, even to this day, evidence of
ghostly apparitions in the vicinity of where the hall used to be.

James and Mrs Tanner never married; nonetheless, they had five illegitimate
children together.

Location: CW9 6AY

Christmas Customs of Cheshire

In former times, the start of the Christmastide celebrations traditionally began on 21 December, the day of the winter solstice and also, at that time, St Thomas the Apostle's Day. The festivities drew to a close on the Feast of Epiphany, 6 January, which was often referred to as Twelfth Night.

There was a popular tradition that always took place on St Thomas's Day, whereby the poor and needy paraded through the parish begging for alms from more affluent parishioners. The rewards given when people were 'going-a-Thomassing', or 'Curning' as it was sometimes known as, were usually small amounts of money, but sometimes they were rewarded with a handful of corn. On these occasions local millers would more often than not grind the corn for free.

In Chester itself the custom of 'Setting a watch on Christmas Eve' was observed. During this tradition, the mayor, together with aldermen, cathedral dignitaries, and other leading citizens paraded through the streets. Before enjoying the banquet at the end of the procession, the Recorder delivered a speech telling of the city's ancient fame.

Many of Cheshire's customs focus on food and the eating thereof. In days long since passed, mince pies at Christmas really were filled with minced meat, which, in addition to various spices, could include ingredients such as rabbit, goose, curlews, pigeon, blackbirds, or whatever else was readily available. Pies were often made to such humungous proportions, with no expense spared, that a single pie could sometimes last and satisfy a family throughout the entirety of the Christmas season – they were very different from today's mince pies! Often called Christmas pies, the pies had a deeper Christian significance, in that they were meant to be a representation of the offerings that the Wise Men made to the infant Jesus. Local tradition claimed that anybody who consumed twelve pies in twelve different houses during the festive period was assured of twelve prosperous months in the coming year.

Frumenty was a kind of porridge, usually made with cracked wheat boiled with either milk or broth. At Christmastide, the dish was often supplemented with eggs, almonds, currants and sugar. The dish was also eaten on Mothering Sunday. After visiting their mothers, servants, about to return to their place of work, were often served with frumenty in order to prepare them for their return journey.

Cheshire cheese also figured in traditional Christmas customs. Towards the end of a festive evening when people were ready to return to their own homes, anyone yawning longer than other people present was deemed to be 'Yawning for the Cheshire Cheese', and was promptly awarded one!

On Twelfth Night, when festivities were coming to an end, Twelfth Cake was eaten. During the eating, two special ingredients were found in the cake: a bean and a pea. The person who had the bean in their piece of cake would then assume the role of king for the evening, and similarly, the person who had the pea lodged in their piece of cake would assume the role of queen. The paper hats found in today's Christmas crackers may even be reminiscent of the time when ordinary folk assumed the roles of kings and queens.

A quaint tradition practiced by the lovelorn was for a maiden to take four large onions and give each the name of her favoured male acquaintances, and then put them in the corners of her bedroom. If any of the onions threw a shoot before 6 January, Twelfth Night, then it was foretold that she would be married to its namesake in the coming year.

Another old tradition was the singing of Christmas carols by Waits. The Waits went from house to house during the season of Advent, singing as they went. Their final outing was upon Christmas Eve when they sang carols and songs in honour of the birth of Jesus Christ.

The Christmas festivities in the great halls of Cheshire were far grander than in ordinary dwellings. It was tradition that on Christmas Eve the yule log was brought to the hall after having been selected and felled on the preceding Candlemas Day. As the log was being dragged along, villagers would readily assist in the task, believing that all who helped would be safe from any harm. During the firing of the yule log, it was tradition for everyone present to drink from the wassail bowl ('wass-hael' – 'to your health'), but all merriment ceased at midnight when the lord and his dependants went to divine service to render homage to the Infant Saviour.

Location: Throughout Cheshire

Vale Royal Abbey

The tranquil and verdant pastures around Vale Royal were very different in former years. The story of the abbey at Vale Royal goes back well before the time of the Reformation, back to the time when Edward I, then Prince of Wales, was returning from the Holy Land. The prince found himself passing through a violent storm and was in danger of being shipwrecked. His crew beseeched him to pray for deliverance. Edward vowed that if he and his people were brought safely to land, then he would found a monastery of white monks of the Cistercian Order. He also vowed that he would richly endow the foundation with goods and possessions. Almost immediately the storm subsided and the ship, together with everyone on board, was safely delivered back to England. The prince remained on the ship until everyone else had departed. He too then left the vessel and, immediately upon leaving, the vessel broke in two and sank.

While Edward had been away his father had quarrelled with many of his nobles, and during the so-called Baron's Wars, Edward was taken prisoner and held at Hereford. During his incarceration, monks from the nearby abbey of Dore ministered to his needs. Moved by such kindness, Edward decided that he should fulfil his vow by endowing their order with a new abbey.

Vale Royal Abbey.

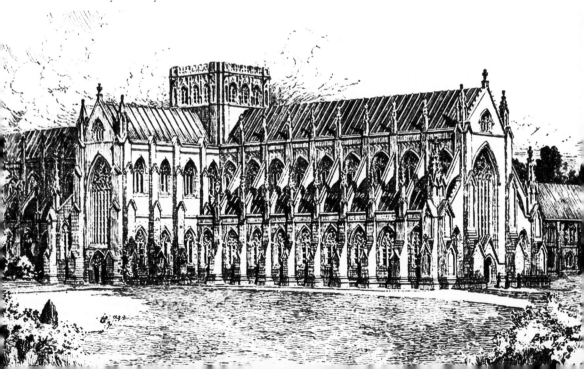

Vale Royal in 1775.

Darnhall was bestowed to the Cistercians in 1270 so that they could build their monastery on the north bank of the new lake. The abbey was also endowed with extensive lands and a number of churches. It was agreed that the new abbey should be built at Over, which from that time was to be known as Vale Royal. The construction of the building had been in progress for seven years before the king was able to lay the first stone of the high altar. The queen then laid another foundation stone, as was the common practice at that time. The abbey cost £32,000 to build, but it was not completed until 1330. In the intervening period, the monks who had left their abbey at Dore were housed in temporary accommodation. John Chaumpeneys was the last abbot of Darnhall Abbey and first abbot of Vale Royal Abbey from around 1275. The second abbot of Vale Royal Abbey was Walter de Hereford. He was greatly venerable in his life, and always devoted to God and the Blessed Virgin Mary. On one occasion when a crowd of armed men disregarded the sanctity of the abbey, the unarmed abbot went out and declared the rights of the abbey, whereupon the invaders promptly turned and fled the scene. The third abbot went by the name of John de Hoo, and, like his predecessors, he too was kind and gentle to all around him. Richard de Evesham was the fourth abbot to rule over the monastery, and he was also a wise and just man. During his years as abbot, it is recorded that there was, for three long years, a terrible famine in the area, resulting in many deaths. The good abbot was given the means to save his people from plague and starvation, and all those who witnessed these events knew that God had looked kindly on the pious abbot.

The privileges that the monks enjoyed were a source of much friction between the abbey and the surrounding villages. In 1321 the tension between the monks and people in the locality became so great that one of the monks, John Beddeworth, was slain and his head was cut off and used as a football. On another occasion, the abbot, Henry Arrowsmith, was hacked to death by a number of local men, including the vicar of Over; the abbot had been accused of raping a local girl. Because of the unruly behaviour of the monks, a senior abbot

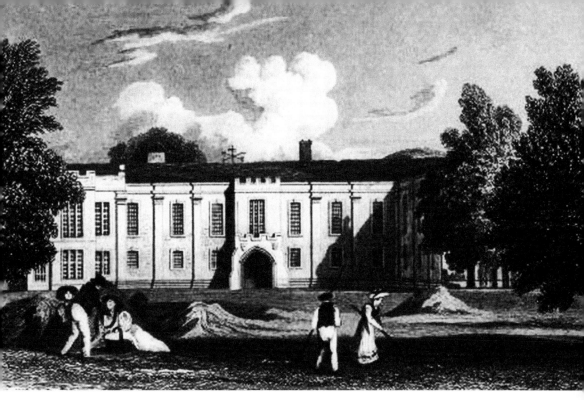

Above: Vale Royal, *c.* 1788.

Right: Avenue leading to
Vale Royal Abbey.

was delegated by the Cistercians to investigate the goings on at the abbey. His report described the activities within the abbey as being 'damnable and sinister'.

In 1535 John Hareware was elected the last abbot of Vale Royal Abbey. Being conscious of the abbey's demise, he rented much of its lands to friends and associates and then sold much of the livestock and timber. In March 1539, Cromwell came to the abbey and charged the abbot with treason. Vale Royal was declared forfeit to the Crown because of the abbot's crimes, but instead of being executed, the abbot and his monks were granted substantial pensions.

The abbey was closed in 1538 as a result of Henry VIII's Dissolutions of Monasteries Act. At that time St Mary's Church, Whitegate – originally the gate chapel of Vale Royal Abbey – became the parish church. Thomas Holcroft, the king's commissioner, bought the abbey and much of the abbey's estates for the princely sum of £450. He immediately demolished much of the complex but retained the south and west cloister ranges including the abbot's house, the monks' dining hall and the kitchens. The Holcroft family and their heirs continued to live at Vale Royal until 1615 when the estate was taken over by the Cholmondeley family.

Vale Royal Abbey today.

St Mary's Church, Whitegate.

Another element in the story suggests that Ida Goodman was a nun at the Convent of St Mary at Chester and when visiting the convent, the abbot of Vale Royal took ill. Ida nursed him back to health, but during his illness the couple fell in love; however their religious vows forbade any amorous relationship between them. It is said that the abbot put a bridal ring on Ida's finger, and vowed that they would be buried next to one another in front of the abbey's high altar. Another version of the legend states that Ida Goodman went over to the Cistercian abbey at Vale Royal to look after the abbot, who was ill. This version also states that they fell in love. However, both versions have since been discredited, as the tale appeared to be 'lifted' from the novel written by John Henry Cooke in 1912 and that a nun known as Ida from Chester convent never actually existed.

Location: CW8 2BA (Vale Royal Abbey), CW8 2BH (St Mary's, Whitegate)

Select Bibliography

Aloin, Cecil, *Old Manor Houses* (William Heinemann Ltd, London)

Andrews, William, *Bygone Cheshire* (Simpkin, Marshall, Hamilton, Kent & Co., Ltd, London, 1895)

Axon, William E. A., *Cheshire Gleanings* (Tubbs, Brook & Chrystal, Manchester, 1884)

Beamont, William, *An Account of the Ancient Town of Frodsham* (Percival Pearse, Warrington, 1881)

Calvert, Albert F., *Salt in Cheshire* (E. & F. N. Spon, London, 1915)

Coward, T. A., *Cheshire* (Cambridge University Press, London, 1910)

Earwaker, J. P., *The History of St Mary-on-the-Hill* (Love & Wyman, Ltd, Lincoln's Inn Fields, 1898)

Earwaker, J. P., *The History of the Ancient Parish of Sandbach* (The Hansard Publishing Union Ltd, London, 1890)

Hall, James, *A History of the Town and Parish of Nantwich* (Mackie T. Johnson, Nantwich, 1883)

Ingham, Alfred, *A History of Altrincham and Bowdon* (Mackie, Brewtnall & Co., Altrincham, 1879)

Ingham, Alfred, *Cheshire: Its History and Traditions* (Pillans & Wilson, Edinburgh, 1920)

Middleton, Thomas, *Legends of Longdendale* (Clarendon Press, Hyde, 1906)

Moir, Arthur Lowndes, *The Story of Brereton Hall* (Phillipson and Golder Ltd, Chester, 1949)

Moss, Fletcher, *The Fourth Book of Pilgrimages to Old Homes* (Baltantyne, Hanson & Co., Edinburgh, 1908)

Nash, Joseph, *The Mansions of England in the Olden Times* (Offices of The Stvdio, London, 1906)

Pennant, Thomas, *The Journey from Chester to London* (Wilkie and Robinson, London, 1811)

Rimmer, Alfred, *Ancient Stone Crosses of England* (Virtue & Co., London, 1875)

Tomlinson, R. W., *History of Sandbach and District* (R. A. Tomlinson, Sandbach, 1899)

Young, Harold Edgar, *A Perambulation of the Hundred of Wirral* (Henry Young & Sons, Liverpool, 1909)

Acknowledgements

While researching and writing this book, I have been given unstinting support and assistance from many members of staff in numerous public libraries across the county for which I am most grateful. I must also give wholehearted and fulsome thanks to the many people who enriched the stories I was researching or passed comments as I was taking photographs of places of interest that feature throughout the text. In particular I must thank Mark Johnston of Nantwich, who helped with my research regarding the Great Fire of Nantwich in 1583. Similarly, I would wish to extend my thanks to Sheila Buckley, who proved to be a valuable source of information and support when I was researching some of the old traditions and customs in and around Sandbach. There are many other people to whom I owe a great debt of thanks, too numerous to mention, but it would be remiss of me not to record my thanks to my wife, Janet, for accompanying me when taking photographs of the various locations mentioned in the text, and also to my son, Jon, who read and corrected the numerous grammatical and typographical errors, as is his wont!

With reference to some of the older images included in the text, I would wish to state that despite prolonged and exhaustive enquiries, tracking down some copyright holders has not been possible.

Finally, while I have tried to ensure that the information in the text is factually correct, any errors or inaccuracies are mine alone.

About the Author

David Paul was born and brought up in Liverpool. Before entering the teaching profession, David served as an apprentice marine engineer with the Pacific Steam Navigation Company.

Since retiring, David has written a number of books on different aspects of the history of Cheshire, Liverpool and Lancashire.

Also by David Paul:
Eyam: Plague Village
Historic Streets of Liverpool
Illustrated Tales of Lancashire
Speke to Me
Around Speke Through Time
Woolton Through Time
Anfield Voices